Dear Gaga,

As I have grown up I've always been the youngest daughter. It has been pretty frustrating at times for me because being raised by a strict hispanic family also comes with stereotypes. Those kinds of stereotypes like "You're a girl, you have to love the color pink, and know how to work so you can find a boyfriend," and I think these stereotypes are complete bullshit. I've never actually felt like I fit into my family; my cousins being the "perfect" hispanic children. It hurts me so bad to hear my mom and dad say that homosexuals choose this way of life and that although they are not homophobic, they wouldn't want one of "them" in the family. Well guess what? Maybe I feel like being a bad kid; a fucking rebel! One day, I will build up the courage to yell at the top of my lungs that I am bisexual and I was born this way. I will be able to think of my flaws, as pure beauty, and I have nobody else to thank but you mother monster. Your music has taught me that the "beauty" in magazines is nothing but fake and that being "normal" is so fucking overrated! You taught me to be a loud, fierce bitch and let my inner queen show. You are my biggest role model and you have filled that deep, cold, empty hole in my heart with love and utter happiness. Thank you so much, for everything you have done and making me see my-self as a new person. I love you Gaga!

Hot Glue Press, LLC
2268 31st Street, #5500
Astoria, NY 11105
212-419-2306
info@hotgluepress.com

ISBN 978-0-9899662-0-7

healthisway.com

First Edition, 2013

Printed in the United States of America
10 9 8 7 6 5 4 3 2 1

Heal This Way

A Love Story

Written By Little Monsters
Photographed by Tracey B. Wilson

Author Tracey B. Wilson

Hot Glue Press, LLC

Thank you to my family and friends for their patience and love as I talked about my belief in this project non-stop.

Thank you to Virgin Mobile and Mother NY for putting me on a tour bus and changing my life.

Thank you to Jim Striebich and Heather Huestis for always having my back.

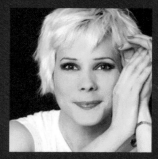

ABOUT THE AUTHOR:

HEAL THIS WAY author/photographer Tracey B. Wilson is a true Renaissance Artist. Working professionally as an actor, photographer, filmmaker, comedian or emcee, all her work is filled with her unique brand of energy and heart.

Ms. Wilson works on Lady Gaga's North American tours, giving high-energy rock-star photo shoots to the Little Monsters in a pre-show performance art event, sponsored by Virgin Mobile. Joining the Monster Ball Tour in the fall of 2009, and continuing with the Born This Way Ball, Tracey has had the privilege of showing thousands of Little Monsters how beautiful they truly are.

www.traceybwilson-inc.com
@littlemnstrpix

Preface

In the winter of 2013, Lady Gaga had to cancel the remainder of her concert tour due to a debilitating hip injury. On the weekend that was to be the Born This Way Ball at Madison Square Garden, Little Monsters from around the world gathered in New York City to celebrate their love and devotion to Lady Gaga, and the community she has given them. Knowing how anxious they were to let Mother Monster know they loved her no matter what, I had an idea. A signup sheet, three tweets, and 100 Little Monsters later, HEAL THIS WAY was born. But what started out as a get well gift for Lady Gaga took on an energy all its own; this project had a voice, and it needed to be heard.

This book is not flawless, but it is perfect. Letters have not been retyped. There is no photoshop. These are the raw words and images of the Little Monsters, laid out for you in all their beauty.

I believe in the empowerment of the words and images on these pages.
My hope is that you will be empowered by them, too.

Artistically Yours,

Tracey

Tilke!
So glad we met! You are amazing! As I tell the kids' —
Mine your differences, they
are your gold!"
bemofgold! ...
♡ Tracey

This book is dedicated to the Little Monsters inside who dared to bare their souls to help heal themsleves and each other. We are forever bonded by this project. I love you.

And to Lady Gaga, for recognizing the power of her words and using them to incite and inspire. Thank you for making this world a more geniune and loving place.

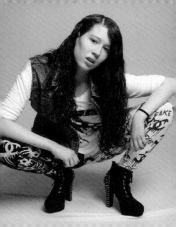

Foreward

It should be said, that the contents of this work were not originally meant to be shared; however, this thoughtful book of photos and fan letters to Gaga emerged as an inspiring and courageous art piece needing to be shared with the world.

Writing our letters, combined with stepping in front of Tracey's camera, was both vulnerable and liberating. The beauty one felt in front of the lens was reflective of her passion to capture more than a simple image. With each camera click, Tracey captured a piece of a soul. She radiated such happiness and joy that the only impression left lingering upon the Monsters was one that spoke of the love she has for us and this project.

Tracey gathered the pieces of us that we willingly and bravely contributed and gave this book life. She formed one soul where each story became a heartbeat upon its pages.

I am so happy and incredibly proud to have been a part of this experience. I believe this book goes beyond just the people inside it. In some ways, this book is a reflection of every human. I believe no matter what your story is, a piece of you can be found inside this book. We are all connected, and I believe we can help each other heal.

Lady Gaga has taught us well. She has taught us messages of love, acceptance, and tolerance - to support one another so that we can change the world. We believe Heal This Way can help.

Darya
Little Monster

All images captured on February 22nd and 23rd, 2013

New York City

Dear Lady Gaga,

They may say I'm a dreamer, but with you, I know I'm not the only one.

Marry the Night has bewitched me, body and soul, and I love, I love, I love you.

Thank you for the comfort and inspiration you have given me. Because your music lives within my heart, I have become a Little Monster through and through. With this artistic faith, you have given me a family with the message of acceptance. On this day, I am surrounded by brothers and sisters who work to understand me, to heal my insecurities. **With this love, we hope to heal you, too.** We love you no matter what you become. That is family.

Heal This Way

With much love & affection,
LITTLE MONSTER
New York, NY

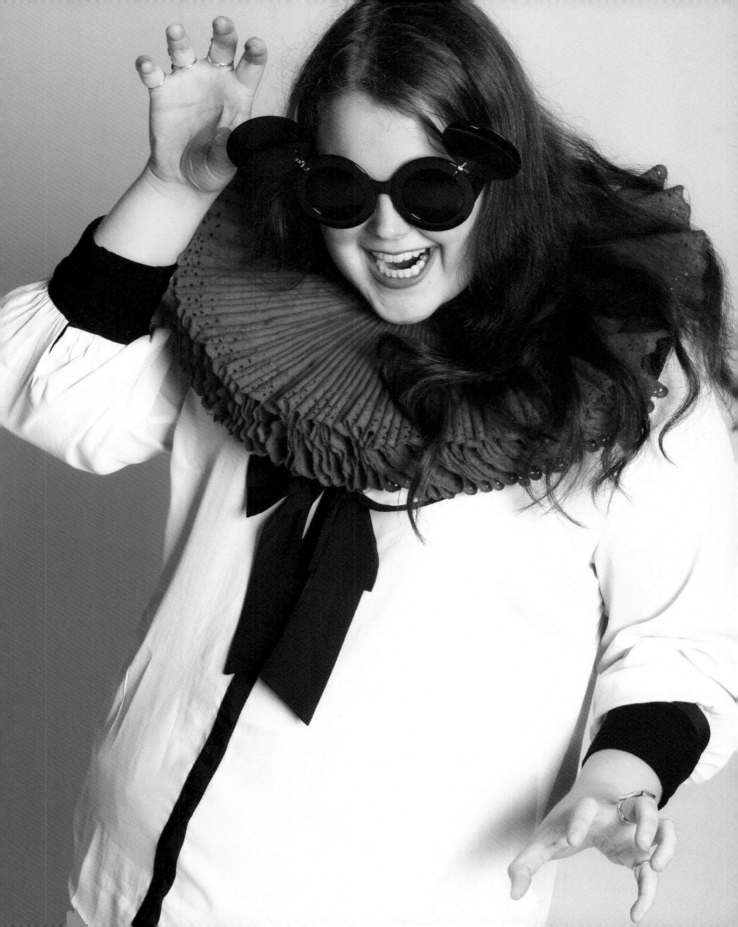

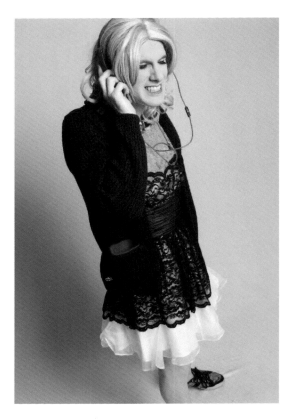

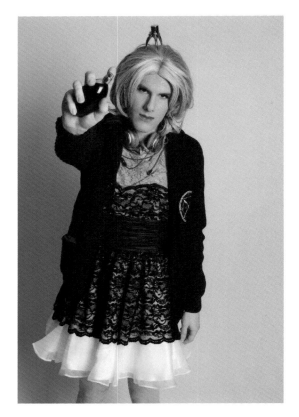

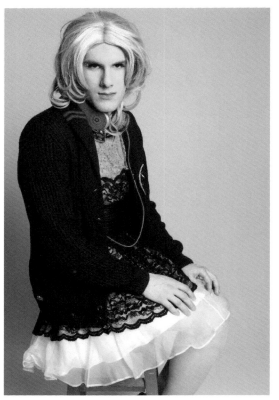

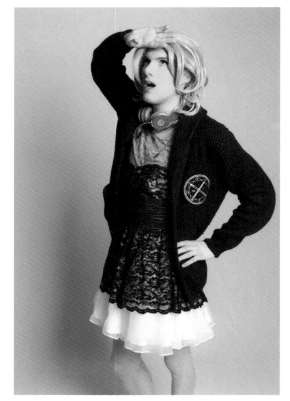

Little Monster, NY, NY

Dear Lady GaGa,

I want to thank you for INSPIRING a generation! For creating a message and a platform that changed not only how gay, bisexual and transgender people are viewed and portrayed in the media, but for creating an incredible positive message for people in any community everywhere!

For years, I have searched to find that one person that I can consider a true role model. I think it's important to surround oneself around a strong support system, especially when times get rough. I'm proud to say I have found that inspiration in music sensation, Lady Gaga. Her image, the messages her songs convey and the love for her fans have helped me in ways that I'm forever grateful for.

Growing up, I always felt different from the rest of my family and friends. I knew they loved me more than anything, but I never felt accepted. If I had a dream or goal that I wanted to accomplish, I could always count on them to shatter those dreams. It's very difficult to hear the people you love dearly say, "You're not worthy of that" or "You can't do it." I never allowed those comments to discourage me. I knew that it would only be a matter of time that I would stand up to them and prove myself.

In August 2008, Lady Gaga released her debut album, "The Fame." It was from that moment my life changed. Her music was like nothing I had ever heard before. While the rest of the world was busy judging her based on her bizarre stage ensembles, I was looking at her as Stefani Germanotta; the person behind the masks. She has such a deep admiration for her fans and treats them like her own family. Through Lady Gaga, I knew that when I wasn't feeling the love at home, I could turn to interviews of her for acceptance. I become alive through her music as it makes me feel free of all my worries. It's because of her that I am now comfortable with my sexuality and overall inner being. I'm more confident and refuse to allow people to tell me how to run my life.

LITTLE MONSTER
white shirt black glasses

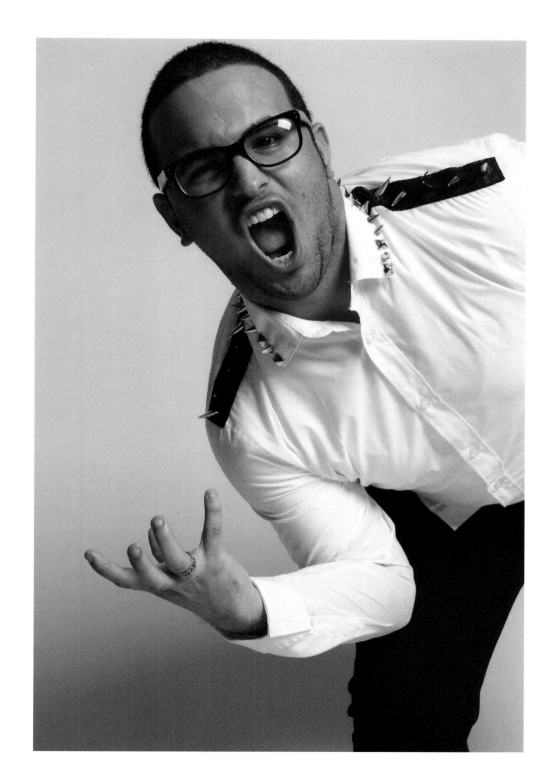

Little Monster
Brooklyn, NY

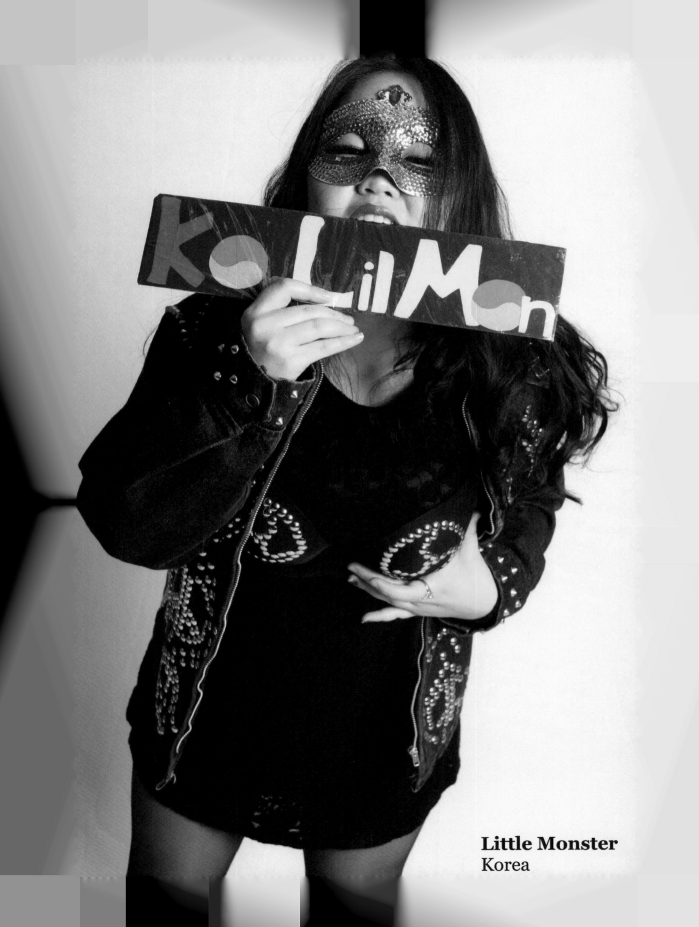

Little Monster
Korea

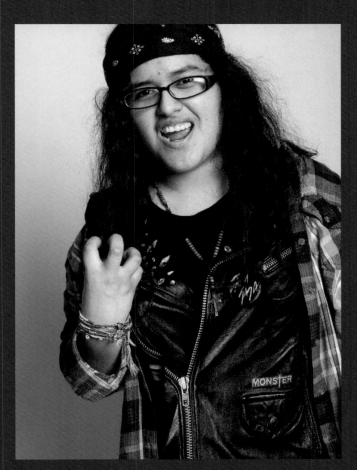

Because of you I've learned that there's nothing wrong with loving who I am, because of you I am living as free as my hair, because of you I'm not as shy as I used to be, because of you nothing scares me anymore.

Little Monster
Lynchburg, VA

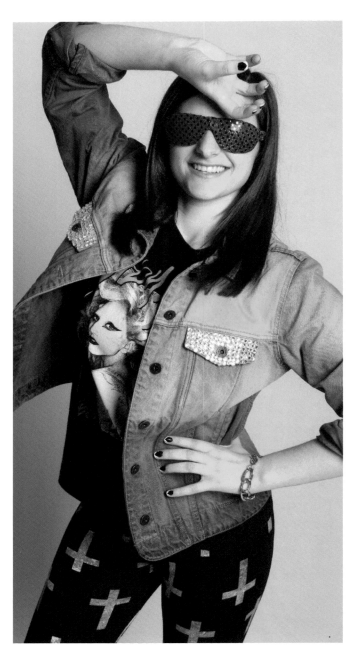

Waterford, CT

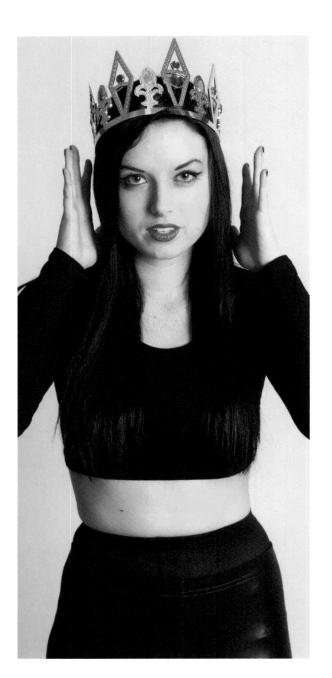

New York, NY

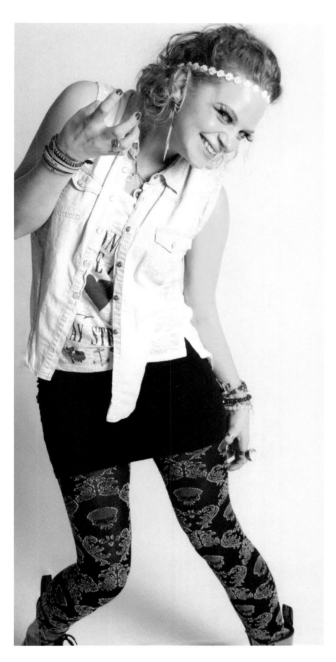

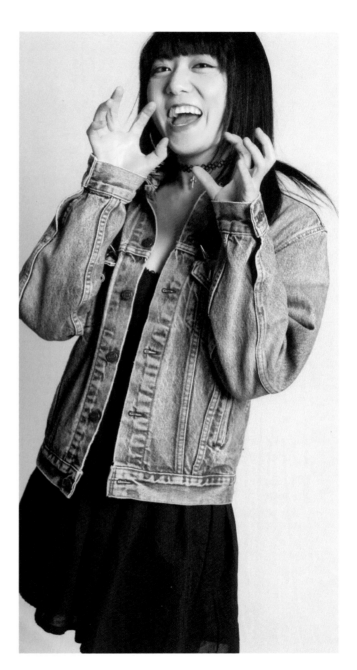

Derbyshire, England

Fukushima-ken, Japan

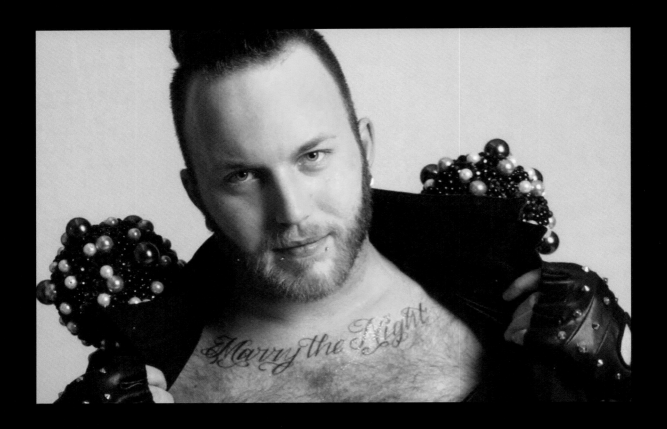

I've never had many friends, throughout my life I've been considered an awkward outcast. My life was flipped upside down, in the most wonderful way, the moment I met the words of Mother Monster. To me being a little monster is the greatest gift, a large group of people searching for the same thing, love and acceptance. The moment I meet another monster, we click instantly. Almost like we've known each other forever, we've both had food thrown at us at lunch, random comments in the hallways...I've seen GAGA in concerts more than a handful of times, it's not just about the music (though it's a great part). THE FANS, the little monster family, we have grown together in a way. I will never forget what mother monster has given me, confidence, a tool to feel comfortable in my own skin. I've never been religious, we are educated to believe that being gay is a sin. Lady Gaga actually showed me I can be spiritual, regardless of my sexuality. I was BORN THIS WAY. I even laugh at myself sometimes, how can one single woman bring so much passion and love into my life. Honestly, the fact she can do that is incredible. She is my queen, and I love her. That will never change. PAWS UP!

xoxo Little Monster, NY, NY
p.s. Heal This Way

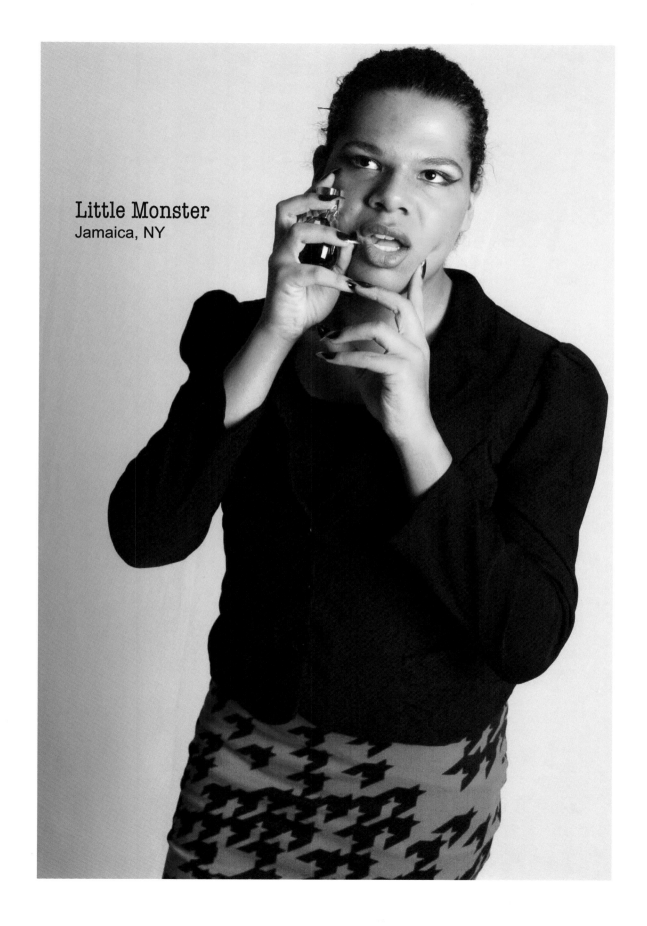

Little Monster
Jamaica, NY

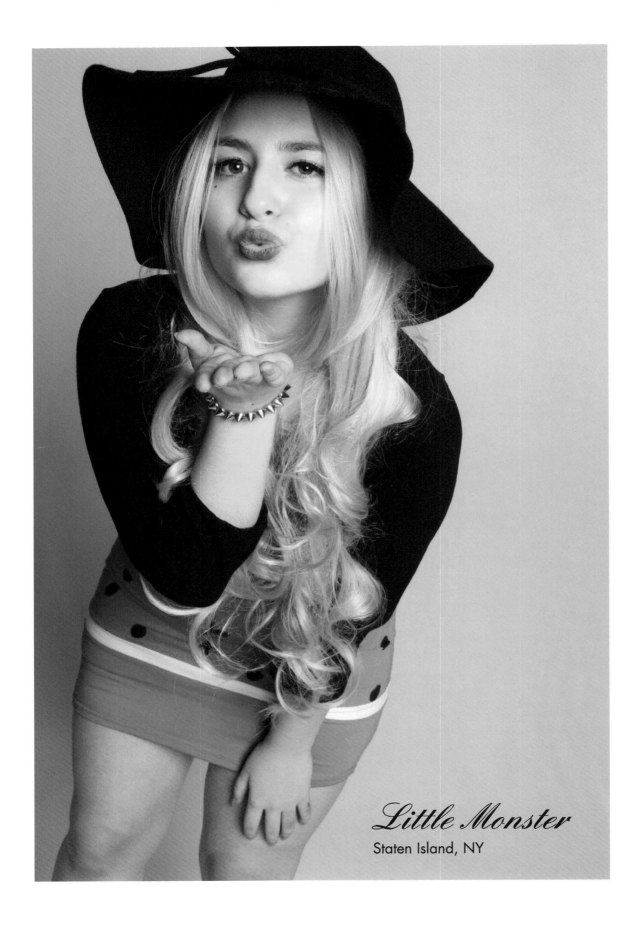

Little Monster
Staten Island, NY

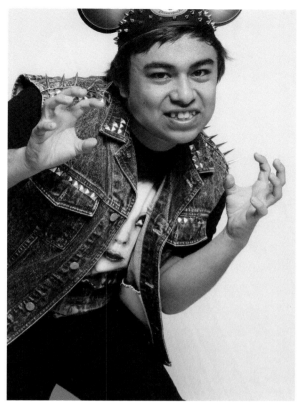

Buena Park, CA
Bronx, NY

S. Plainfield, NJ
Pleasantville, NY

i know you hear this all the time, but you truly saved my life. I've been severely bullied about my weight ever since I was in 3rd grade, and ever since I've been extremely insecure. I was, and still am, called fat, cow, whale, useless, worthless, freak, gay loser, ugly, etc. Ever since you've come into my life, you've made everything better. My freshman year of high school was the worst. I really wanted to fit in but it just didn't work out that way. I thought maybe the bullying would stop, but it just increased. I would get notes in my locker saying I'm worthless and to kill myself. I just wanted to end my life. I was going through a lot at the time, I was cutting, I just couldn't handle being here anymore so I tried to take my own life. But then I thought of you. Every thought about you was rushing though my head. "What if she found out?" What if she finds out she lost another monster, etc. I thought about you a lot. And I thought about you singing Hair in tribute to Jamey Rodemeyer. And I stopped myself.

On Nov. 22, 2011 I met you at the terry x gaga book signing and I thanked you for saving my life and you rubbed my back and told me:
"honey, don't cry, you save my life every single day"
I will honestly never forget that day.

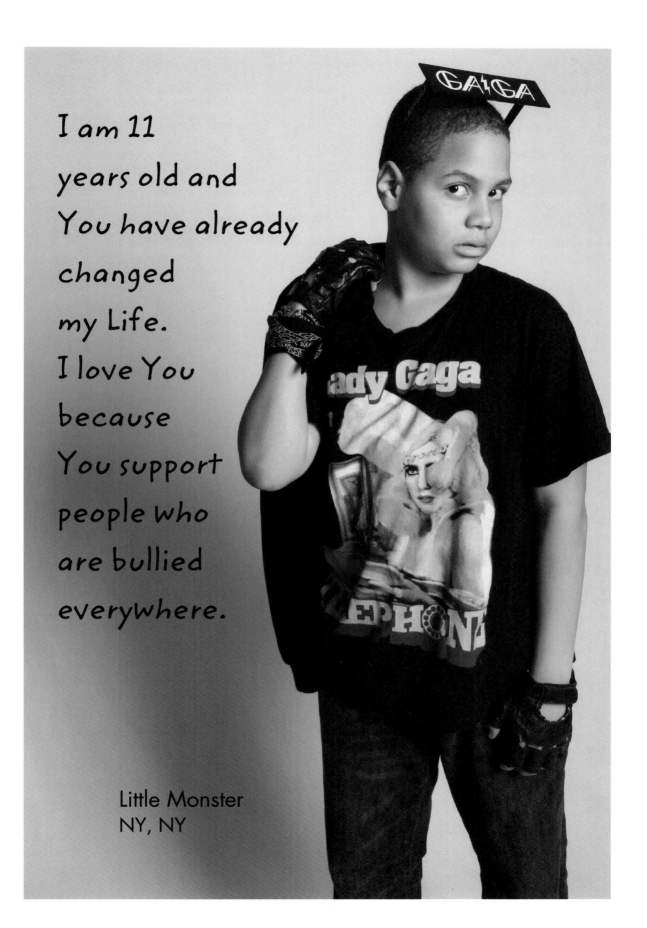

I am 11 years old and You have already changed my Life. I love You because You support people who are bullied everywhere.

Little Monster
NY, NY

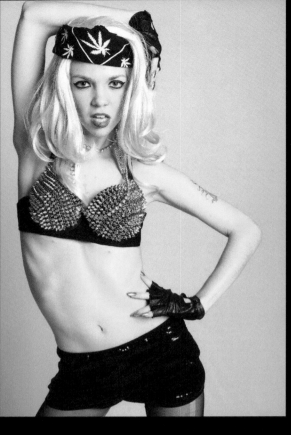
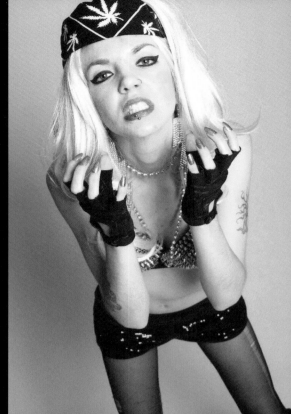

You have helped me in so many ways. You opened my mind to art concepts that move and inspire me endlessly. You have helped me stay strong. I have struggled with so much in my life - body issues, self mutilation, abuse. I was bullied for the way I dress, and my sexuality for at least six years of my childhood and adolescence. I struggle with Major Depressive Disorder and Panic Disorder along with addiction problems. But your music, your message, and your bravery, your ARTPOP, and your existence in this world help keep me strong.

I know you can Heal This Way. I will always believe in you.

LITTLE MONSTER, Buffalo NY

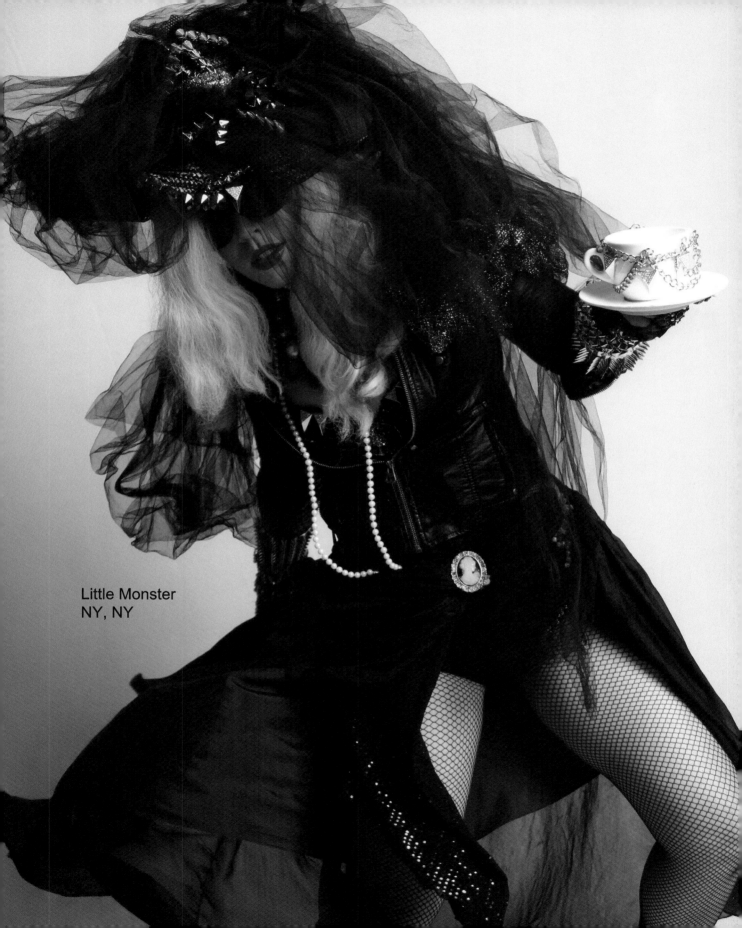

Little Monster
NY, NY

The Little Monster pictured here
asked to be removed.

Even though he was of age
and a gorgeous human being,
he was afraid his parents would "find out."

It breaks my heart.

That is why we made this book.

Dear Gaga,

I want to say that I love you so much. You made me brave and strong to continue living my life. I used to get bullied because I wasn't "normal" in societies eyes. People would tell me that "I walked like a girl" and it wasn't the right thing to do. I unfortunately believed these lies and was always sad and felt like I was no one in this world, but you have changed my perspective on the world, you tell me that I was born this way and that we should be proud of who we are. I want to let you know that I will always support you no matter what. You mean the whole world to me and my love for you is eternal. Whenever I see a picture or hear a song from you, I start getting emotional because you make me feel confident. I didn't have a good past. I have little memories of being happy. All of them are mostly bad, but that's why I want to continue in the present and be who I was born to be. I was born to be brave and you have showed me the way into the light. I call you my "Little Gaga" because you're so beautiful and cute. You make me happy enough to call myself a "little monster" and actually mean it. I know you are going through a tough time right now, but I want you to know that I'm here for you! I've been praying and wishing good things for you. I feel like I have the responsibility to look after you, like you look after us. Sometimes I get really bad thoughts on giving up, but then I go on Twitter and Littlemonsters and get support from monsters all over the world. It's true, they are my monster family and Gaga you are my queen and my mother monster. Thank you for being there for me and making me strong, I love you and I will never leave you. Please, you need to get better and heal this way for us. I love you my Gaga. Paws up, mommy monster!

By: A Brave Little Monster

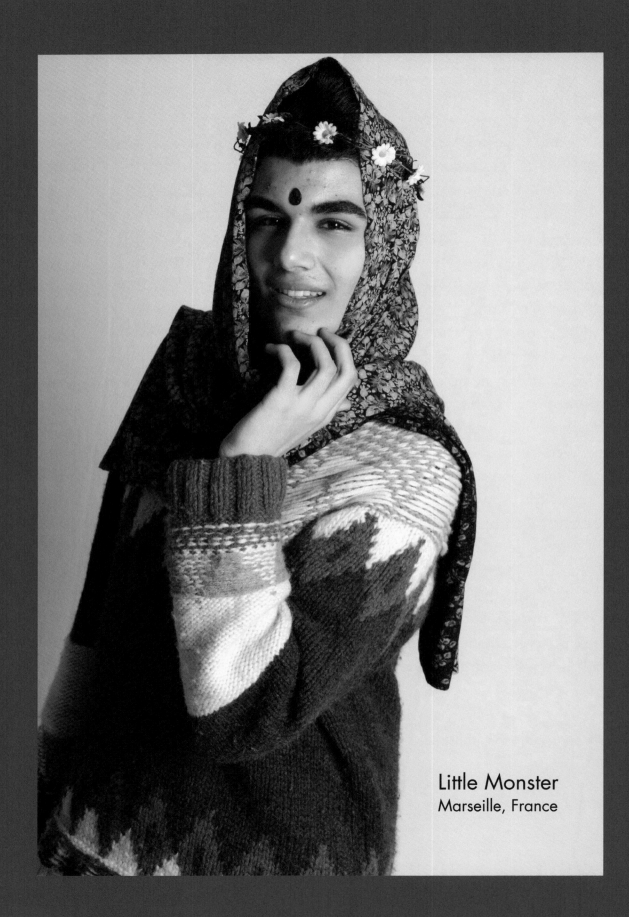

Little Monster
Marseille, France

Little Monster
Elmhurst, NY

Gaga,

I have, Since I remember, have been living in the dark. In a world where I did not accept my self. Then Born This way Came into my life and I understood that it is okay to be who you are. I finally knew I was Born this way. You helped me shape who I am now and I want to Thank you so much. I Love you gaga and I hope you get better and you keep Kicking ass. I cannot wait for ARTPOP

Love, your little monster

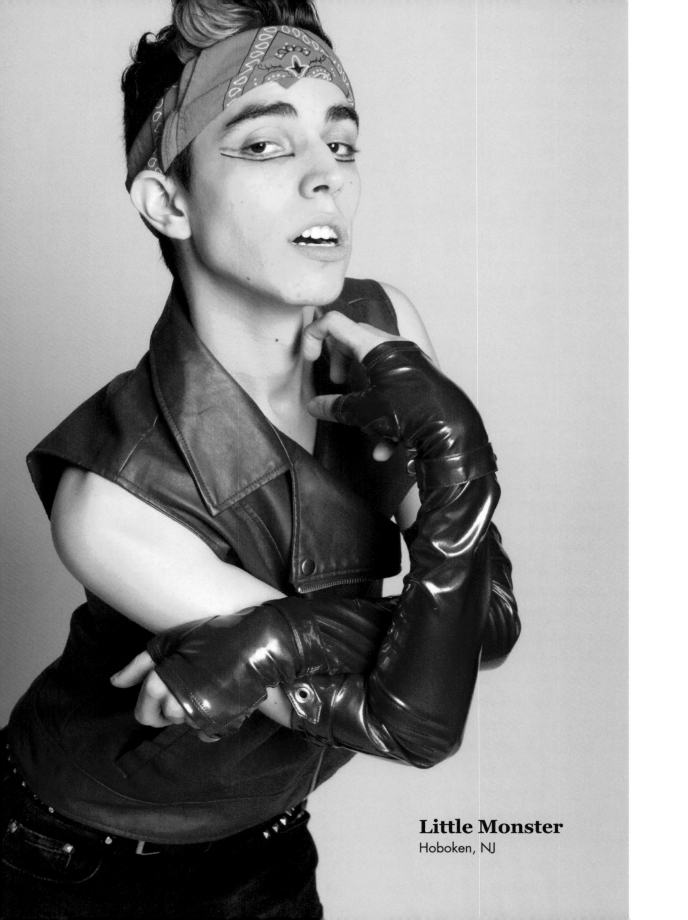

Little Monster
Hoboken, NJ

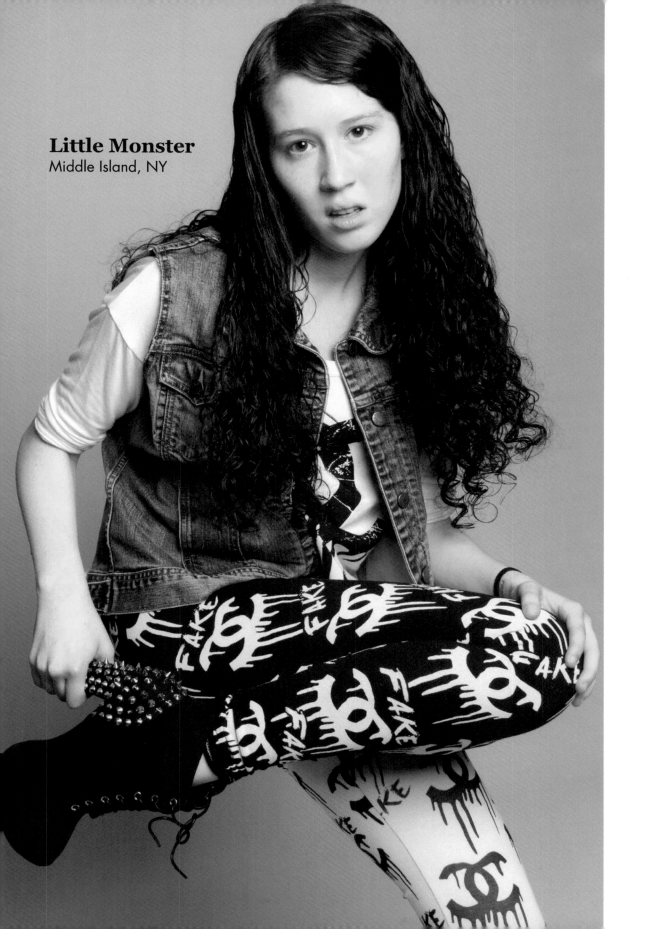

Little Monster
Middle Island, NY

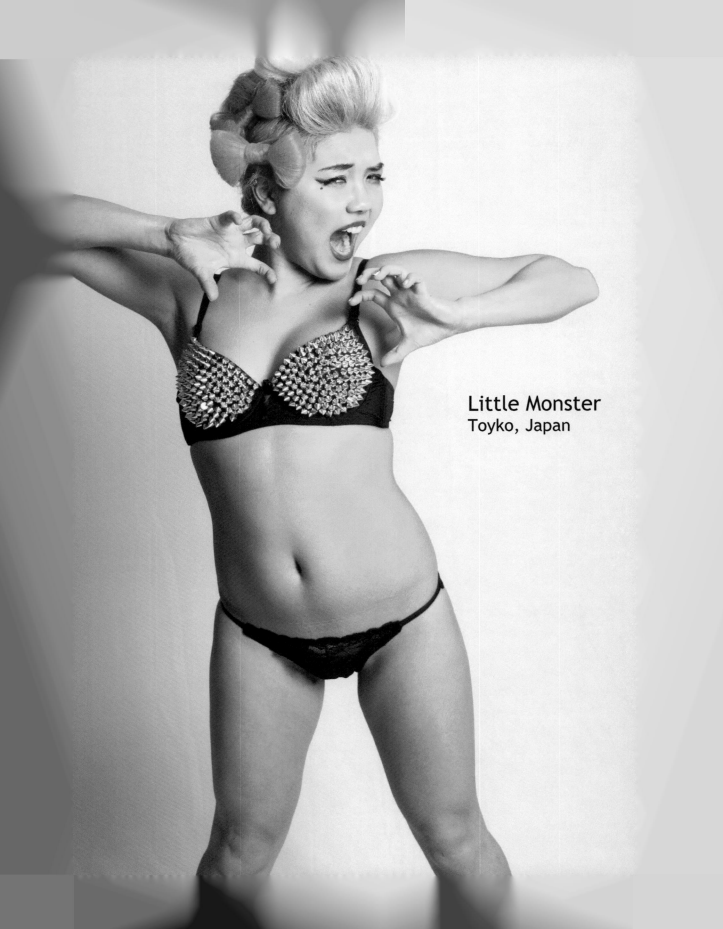

Little Monster
Toyko, Japan

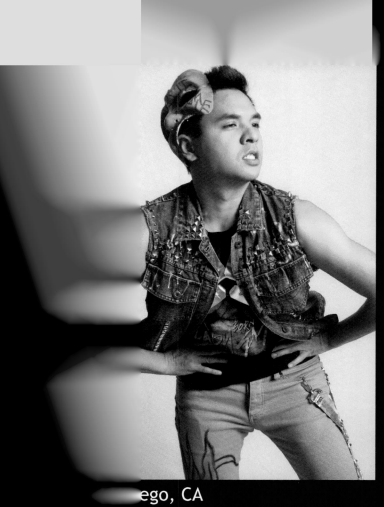

San Diego, CA

San Diego, CA

I HAD TICKETS TO SEE YOU ON MY 30TH BIRTHDAY @ MADISON SQUARE GARDEN ON FEB. 22ND 2013. NOW WHAT I WANT IS FOR YOU TO HEAL. YOU HAVE DONE SO MUCH FOR ME & ALL YOUR LITTLE MONSTERS & I WISH WE COULD DO MORE TO HELP YOU. YOU HELPED ME BE BRAVE ENOUGH TO GO OUT & MEET THE MAN I LOVE. PAWS UP FOR EVER!

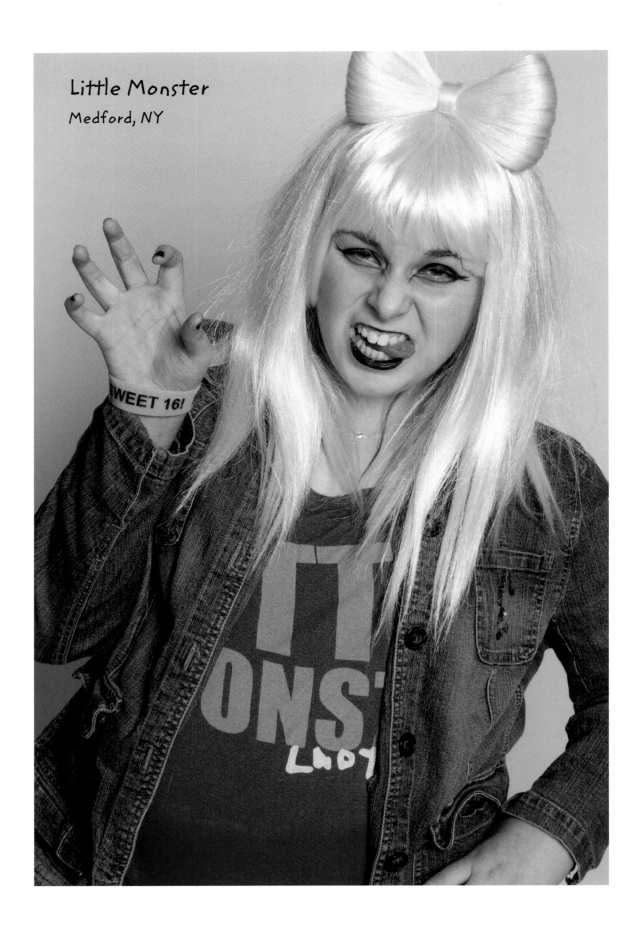

Little Monster

Medford, NY

I am not the most popular kid, and I do get judged on the spot, but it doesn't hurt me anymore because of you. If someone says something that hurts me I just smile and say, "Bitch, you need Lady Gaga in your life!" Then I put my poker face on, and my paws up.

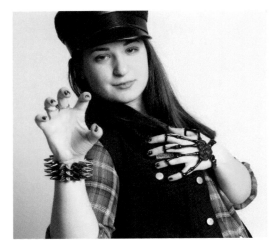
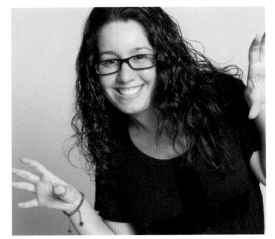
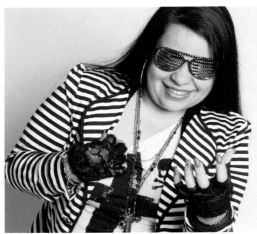
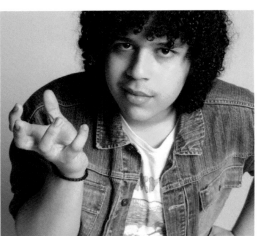

Evans, GA
Inwood, NY

Staten Island, NY
Brooklyn, NY

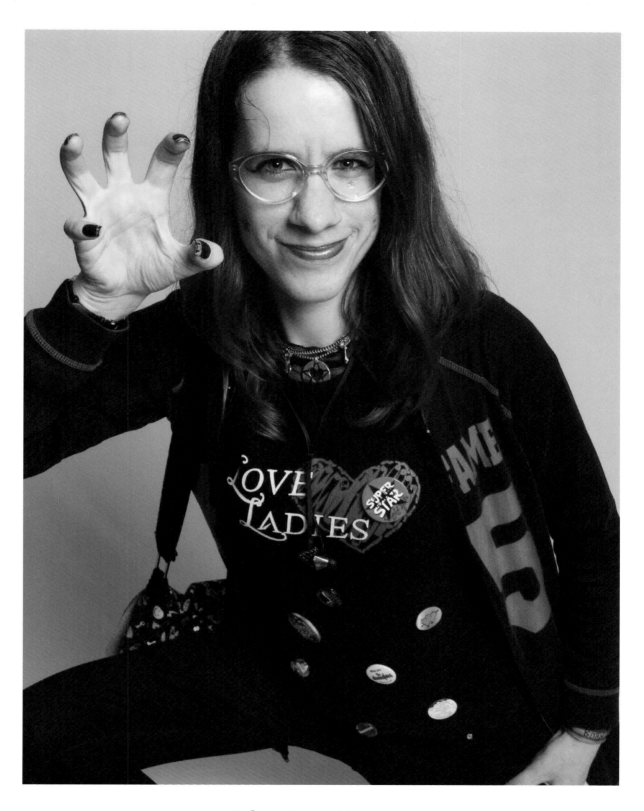

Little Monster

Amsterdam, Netherlands

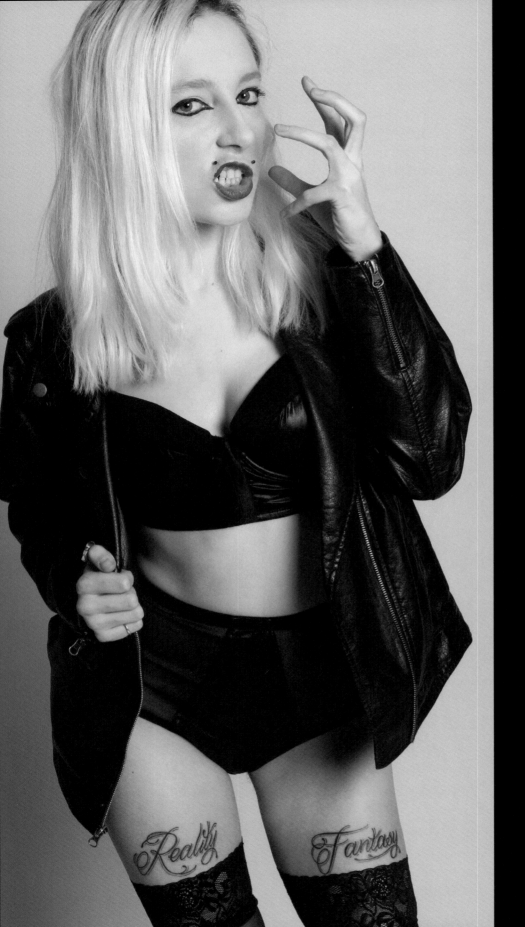

Little Monster
London, UK

My Dearest Gaga,

Right now I am sitting in a hotel on West 35th right near Macy's. I came over to NYC with my boyfriend to support you at the Born This Way Ball at MSG, I live in London but I had to make it to a Ball at MSG because then I would be a true *Super Star*. The news I received a week ago however broke my heart. I sat up in bed staring at my laptop. I didn't know what to do. I was too shocked to cry and too scared to allow myself to believe that what I was reading was true. You were hurt. You were injured and in pain. The word 'cancelled' meant nothing, I didn't care. That wasn't why I wanted to cry, I was heartbroken because you, my strong, bad ass idol, had been pushed too far. I couldn't bare the thought of you being in pain, I watched your last performance of Scheibe over and over, that scream and you falling to the floor, I couldn't bare it.

You give hope and inspiration to all of us Little Monsters, you have built us up to be so strong and brave, you have transformed us into a powerful community of loving and caring people and now it's our turn to show you how greatful we are for that. You mean the world to us- no- you ARE the world to us and we are here for you, to help you through this.

Don't feel guilty, don't feel like you've let us down. Don't feel like you have to rush back to the spot light, it will wait for you. Take your time, stay with your family, give your body the time it needs to heal. Look after you the same way you would any of us. We love you so much Gaga and we will take this journey of recovery together. You are never alone.

We love you.

For much of my life I have been afraid of being who I truly am. This is a common fear which is why I am not ashamed of saying it. What I am ashamed of is that for a long time I felt as if I had to hide who I truly was because of this fear. When I discovered your music, I was in a very vulnerable state. Being one of the only people I knew who liked the same sex was hard for me. I thought that I was a bad person for having these feelings, and for a very long time I felt as if I was not worthy of being a part of society. This is when you came into the picture. You lifted me up from the ground with your music and I could honestly say that I was truly happy. Now I know that it is okay to be who you are. I am no longer afraid to dance in the dark or to be a bad kid. I know who I am now, and I will never let myself go back to the way I was. I love you for all you have done for people like me, people who we lost in life, people who didnt think they were "normal" enough to be part of society or this world. You have saved many lives and for this I am thankful. I am wishing you a speedy recovery and I cant wait what you have in store for us in ARTPOP. Maybe one day I will be able to meet you in person and tell you all of this. For now I just want you to know that I love you and that you have filled a hole in my heart that was empty, and for that I am truly grateful.

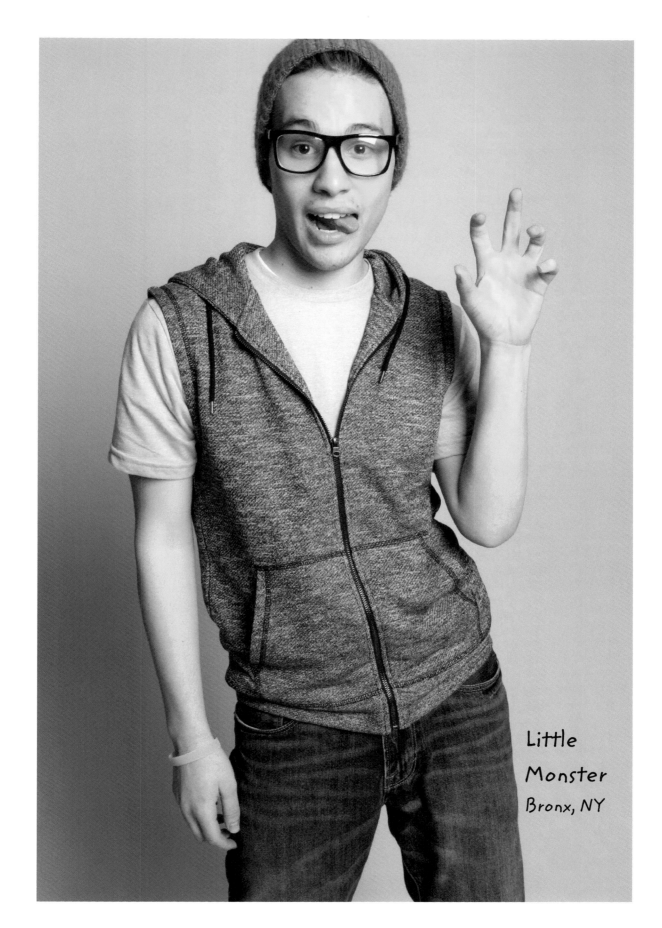

Little
Monster
Bronx, NY

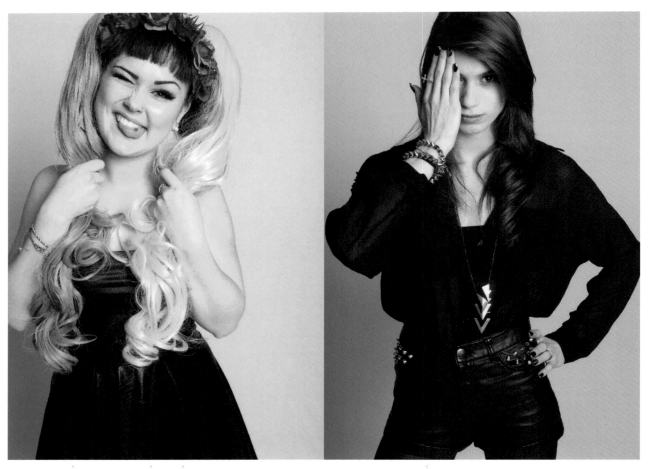

Nottingham, England

New Castle, PA

you have inspired
dreams and to try
things people

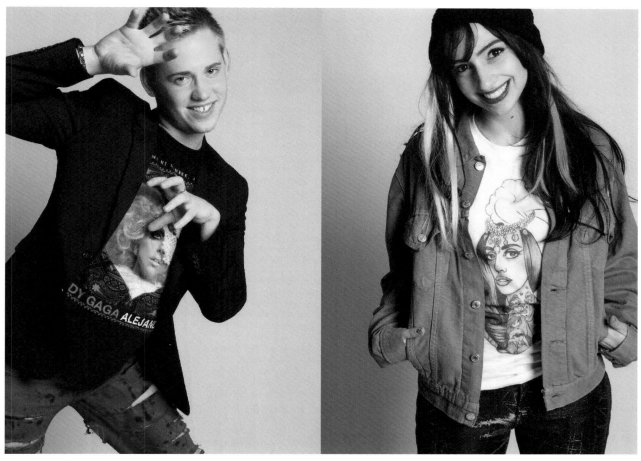

Chantilly, VA

Brooklyn, NY

us to follow our
our hardest at
say we can't do

Lady Gaga has impacted my life in more ways than I could have ever imagined. She has been a constant source of strength and inspiration to me. She is an example of the person that I want to become one day: hardworking dedicated to her craft, constantly striving to improve on what she`s previously done. Because of her I am always trying to push myself to do better and be better.

In addition to being a source of inspiration, Lady Gaga's positive outlook and message have helped me to become a more positive person. I've deal with depression for over half of my life and I've never had anyone to talk to about it, or to help me with it. I come from a family that doesn't like to discuss anything uncomfortable; it all gets swept under the rug and ignored like nothing is wrong. One of the ways that I've tried to cope with the depression is turn to cutting When I feel like one of my "dark moods" coming on. I'll put on Gaga`s music and all my problems seem to disappear, if only for a little while. I imagine myself away from all the loneliness and negativity.

Probably the biggest way that she has impacted me would have to be helping me accept that I'm a lesbian. Before I heard 'Born This Way', I felt ashamed and I longed for something to make me feel proud of this part of my identity. The first time I heard her sing, "No matter gay, straight, or bi, lesbian, transgendered life/I'm on the right track, baby, I was bom to survive", I got chills like she was singing that line directly to me. I haven't come out to my family and not sure if I ever will; I'm terrified of how they would react if they knew. I have come out to my friends and I'm definitely more open about it to other people and I have Gaga to thank for that.

Since Gaga has helped me with so much in my life it's fitting that her and her music will be playing an important role in my next challenge. When I saw the posts and pictures about the Body Revolution, I was amazed by all the different people posting their own pictures and telling the world that they love their bodies. Inspired by the Body Revolution campaign that she started, I'm going on my own Body Revolution and will be losing 90 bs. I'm not doing it simply to look better in clothes (though that will be an added bonus); I'm doing it to improve my health. I also hope to finally love myself and find the self-confidence that has always seemed to elude me. I also want to get back to one of my first passions, which was dancing. I currently can't dance as well as I want to because of my weight and I become winded too easily. I watch Gaga's performances and it makes me want to jump right up and join her!

Lady Gaga means so much to me and countless others. She has helped numerous people through her music, her positive message, and just being herself. I can only imagine the number of people whose lives have been affected in such a positive way, as she has done to mine. I'll forever be thankful and a Little Monster.

By: Little Monster Hillsborough, NJ

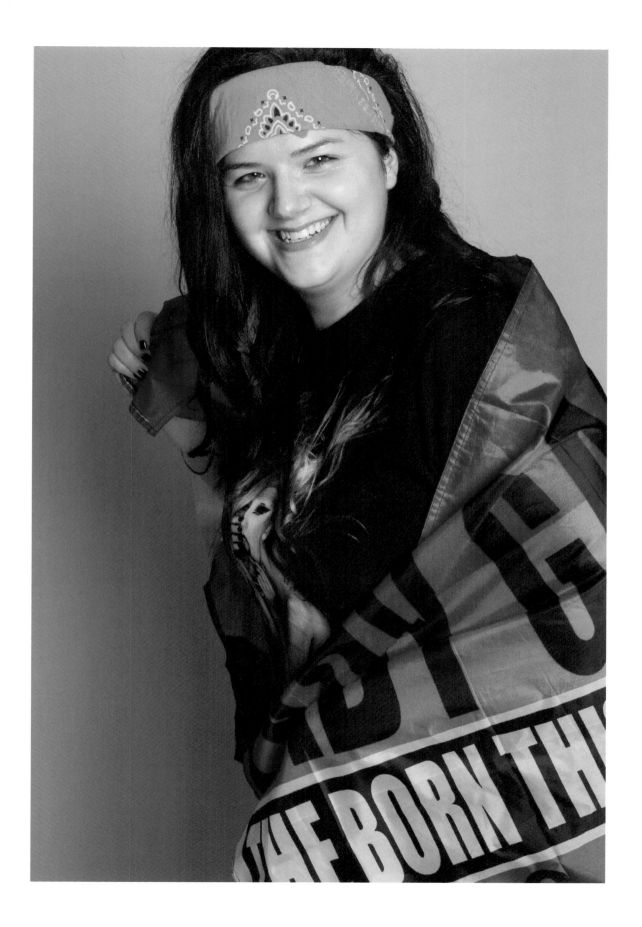

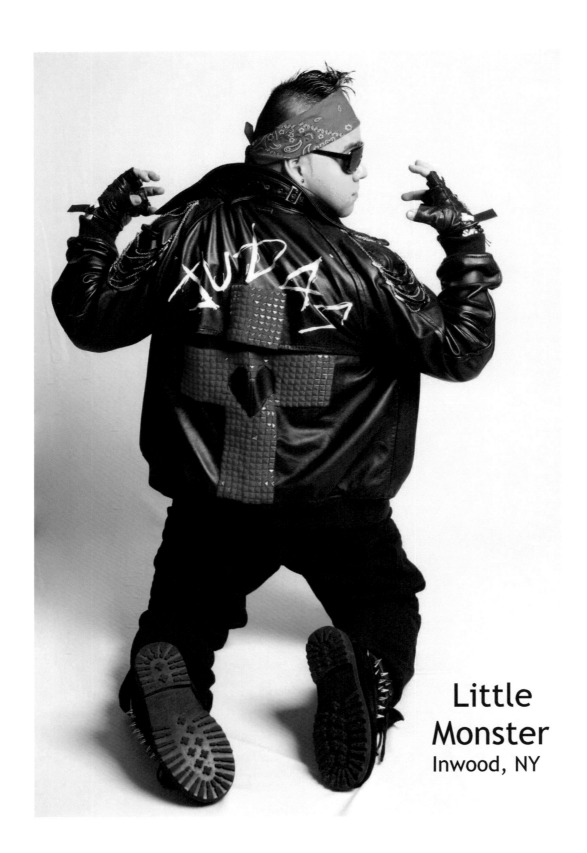

Little
Monster
Inwood, NY

I can't explain to you how much joy I get when I walk into the most random places and one of your songs starts playing. I stop and break into choreography on the spot.

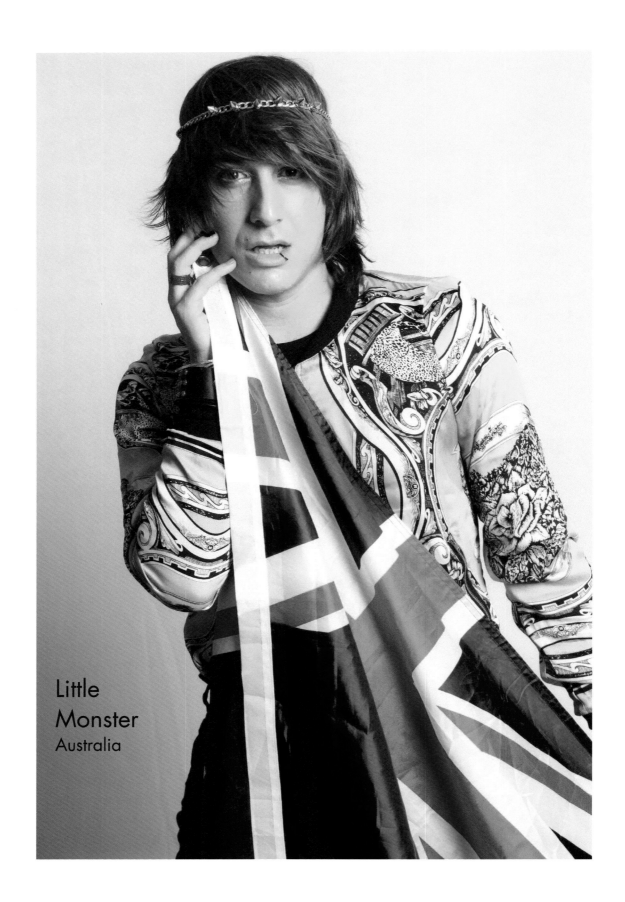

Little
Monster
Australia

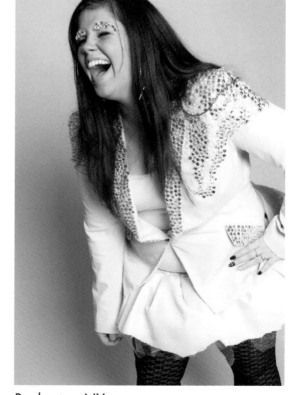

Brick, NJ

Rochester, NY

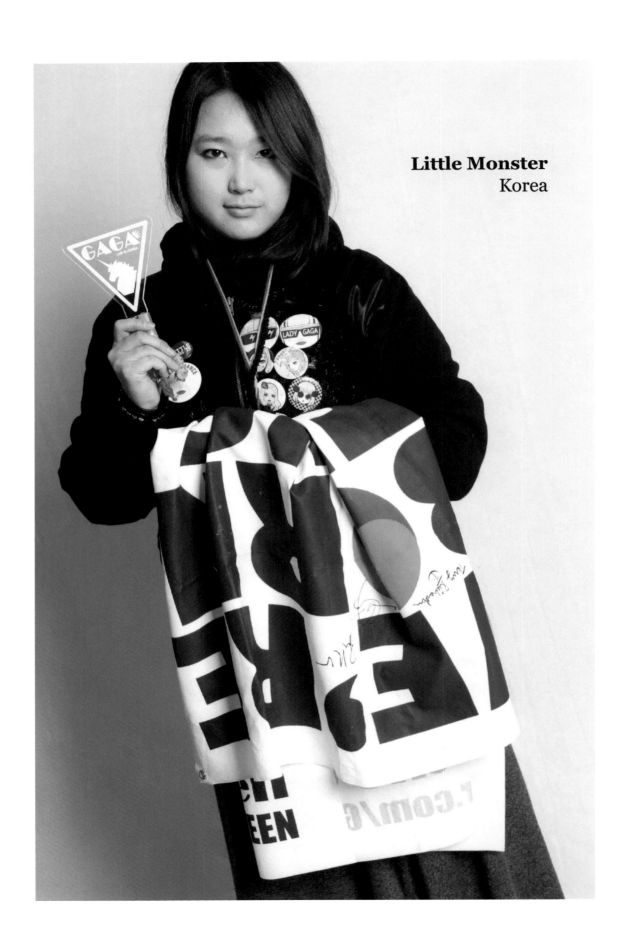

Little Monster
Korea

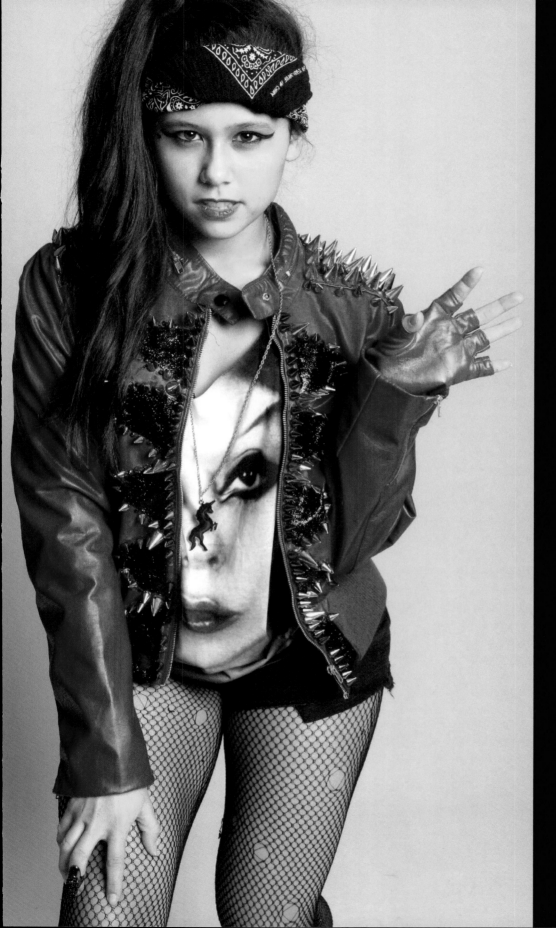

You are inspiring, talented, and the person I choose to look up to.

You also inspire my creativity a great amount.

I want to thank you for always being so fierce and fabulous.

Little Monster
Mineola, NY

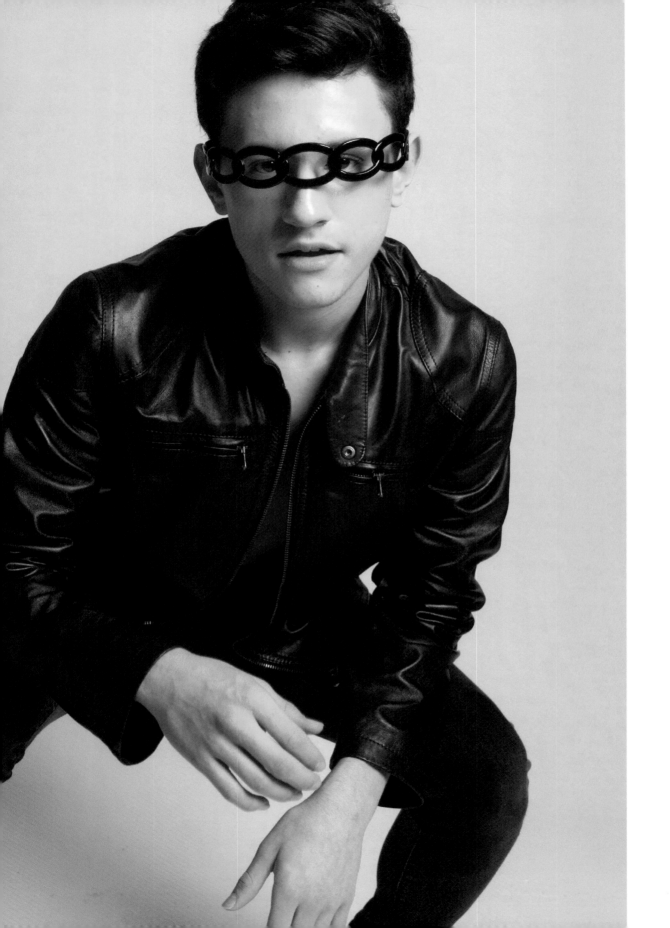

It's quite strange how this works, really. I've spent the past hour staring at a bank document on a computer screen, trying to figure out the perfect way to articulate exactly how much you mean to me. What I've realized is, however, is that it is impossible. Thoughts of mine are quite profound while in my head, but expressing them in a condensed form is not something that comes easy. I guess that's one of the many things that make you a true visionary. You are able to take those twisted, tragic, beautiful thoughts floating in your head and artistically express them for your audience to decipher, admire, and enjoy. You, my Lady, are a true Artist. Gaga, I need to thank you, basically, for everything. You are my inspiration not solely because of your dedication to love and freedom, but also from an artistic standpoint. I've learned that life is art. For me, you have blurred the line between onstage and off. Life is a performance, full of POSSIBILITIES. I have been performing for most of my life, and I can truly say that I have never been more inspired by someone's work ethic. **I model myself after what I could only assume was your mantra when living on Stanton Street on the LES; keep going.** Whenever I find that I doubt myself, or second-guess myself, I think of you. Truly, I do. I think of your ambition to achieve your dream. That's what life is about to me. I'm graduating high school in less than a year now, and after so much confusion, depression, and genuine unhappiness, I've decided what I want to do. I'm chasing my dream. I live for art; I cannot do anything else. I'm going to get myself some shitty apartment, work my ass off, go to a billion and two auditions and it will pay off. Thanks to you, Gaga, I have the confidence to follow my ambition. My insecurities will no longer get in the way of my happiness. And that is the ultimate goal, isn't it? Happiness? It seems so simple, but it's something we all strive for. I'm so grateful I have finally found my path to happiness; I completely credit you for that. On your road to happiness, you also taught us a very valuable lesson: confidence co-existing with humility. Unfortunately, many people don't think it's possible for these two ideas to live in the same realm, so thank you for teaching me that being humble, yet strong gets you far. With that being said, this may be the first time you're hearing my name, but l will make sure that it will not be the last. **I'm going to make it, and you'll be the first person I thank.**

I find it really rad how revealing and open I can be with you. We have never physically met, yet I feel so connected to you. You are both my queen and my friend. You will never truly understand how thankful I am for that connection, and how much that means to so many people. I love you. I really hope this message was able to make you smile. Please, please take your time to recover and feel better. Nothing but good vibes for the next chapter. **You're changing the world, Gaga. Believe in yourself.**

Love fellow New Yorker/pop culture junkie/superfan/friend:

Little Monster
Smithtown, NY

Milford. DE

Greensboro, NC

France

Middlesex, NJ

...your music and your story has help me, when I see you I feel safe, I feel protected, I feel that at least one person loves me for the way I am, I feel strong, I feel free, I feel so many other things I can't explain, you brought a meaning to my life, **I don't see you like a pop star. I see you like one more of our generation, one more fighting with us to have full equality,** and you have giving a voice to thousands of young people who were repressed by their religion, government, or family, so I would like to thank you for making this world a better world, I love you sooooo much, I hope to see you live during your next tour, I can't wait for ARTPOP I'm sure it will be amazing, and I promise to always be here for you, in good and bad times, don't worry I will never betray you,

LITTLE MONSTER FOR EVER
Queens, NYC

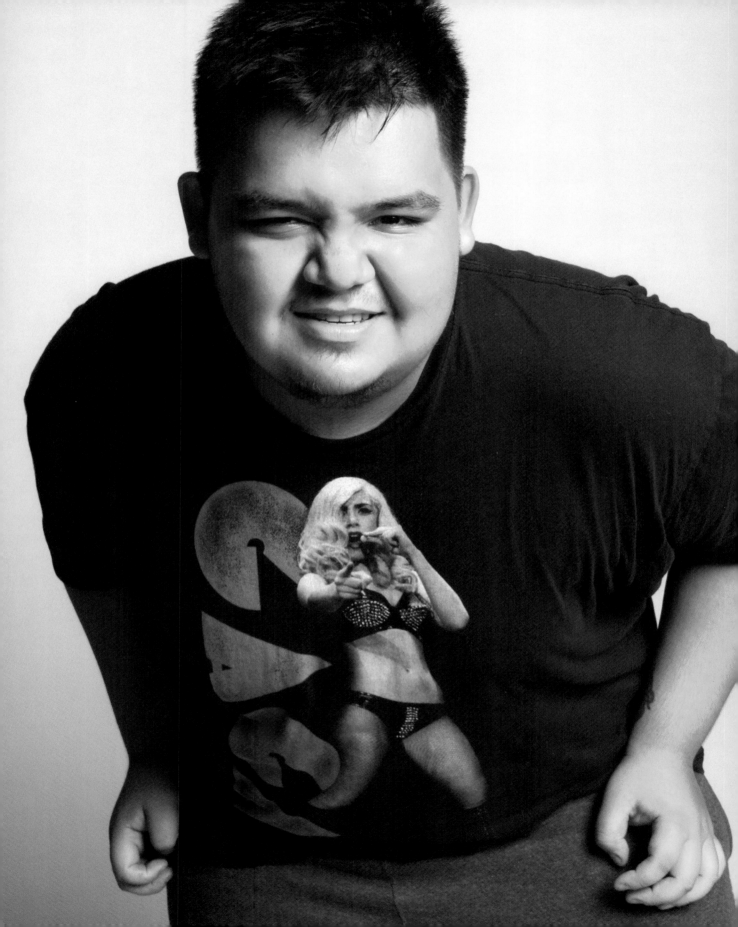

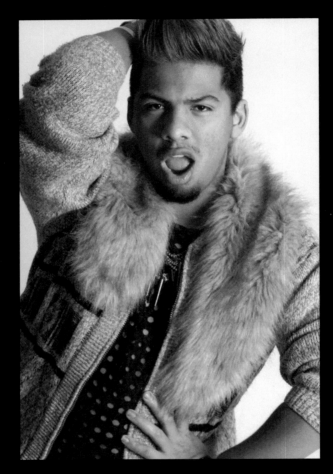

Little Monster
Garfield, NJ

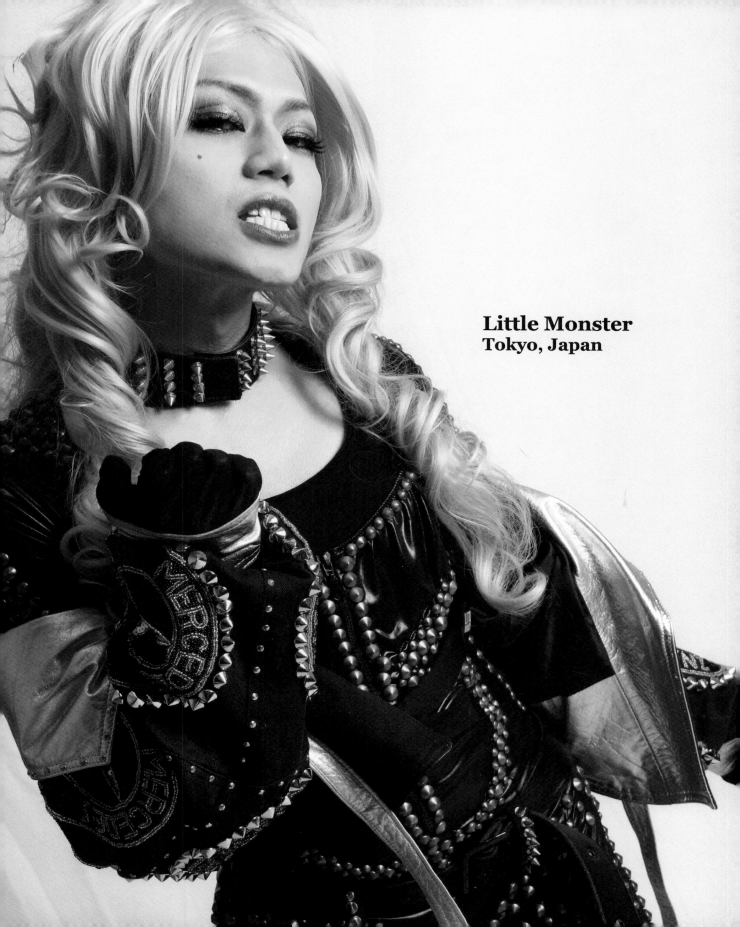

Little Monster
Tokyo, Japan

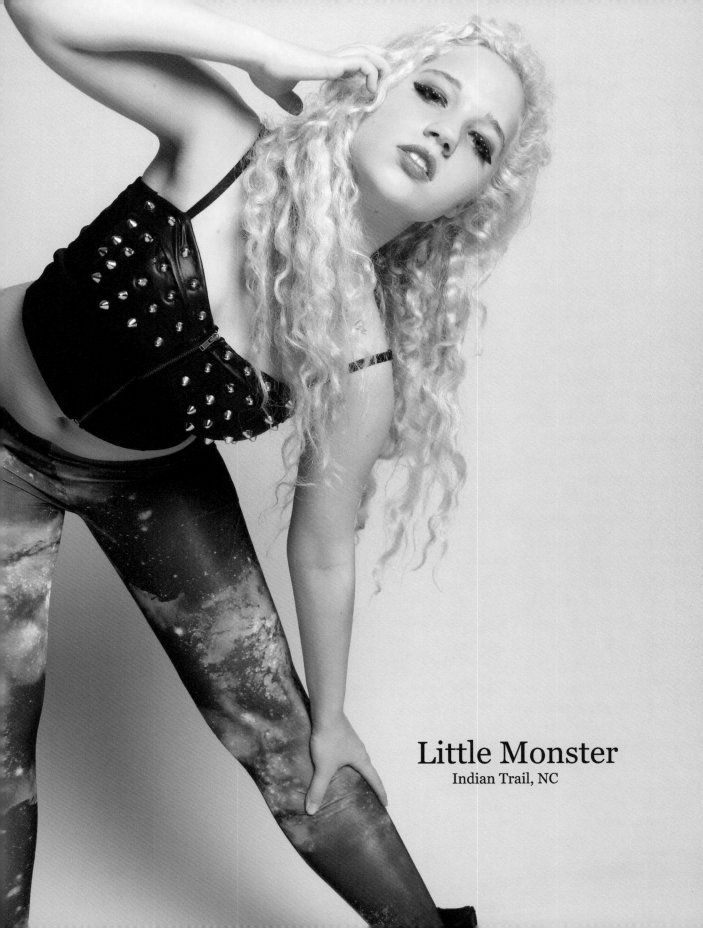

Little Monster
Indian Trail, NC

I used to have hot pink hair.
Upon your advice, it is now turquoise.
I am me.
I hold no contempt for any part of myself.
I hold no contempt/judgment of others.
I believe your art and passion are what we live for.
You are a beautiful soul with a beautiful mind and voice.
Because of your existence, I am the truest me there could ever possible in eternity be.
You saved me from dissolving into the useless blob society tries to mold us to be.
You have the ability to produce effective change in the world - and you have...in my life and positively in so many others.
Because of you, I believe I can do this to.
I'm thankful for our time on Earth together though we know little of each other personally.
Because of you I have seen the freedom in self-expression while I was going up.
I love you.
I believe you love me too.
I want you to heal and focus on you.
Please, if nothing else, find comfort that you have helped me in inexplainable ways that can never be explained in a word/phrase.

LOVE, A DAMN PROUD LITTLE MONSTER♥

You have taught me that beauty in magazines is NOTHING but fake, and BEING NORMAL is SO fucking overrated!

A Fierce Little Monster

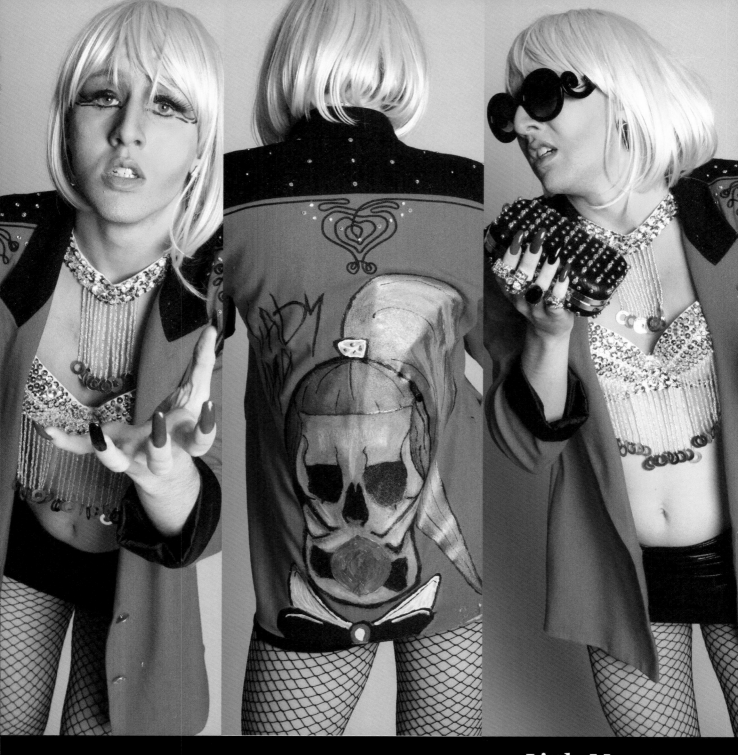

Little Monster

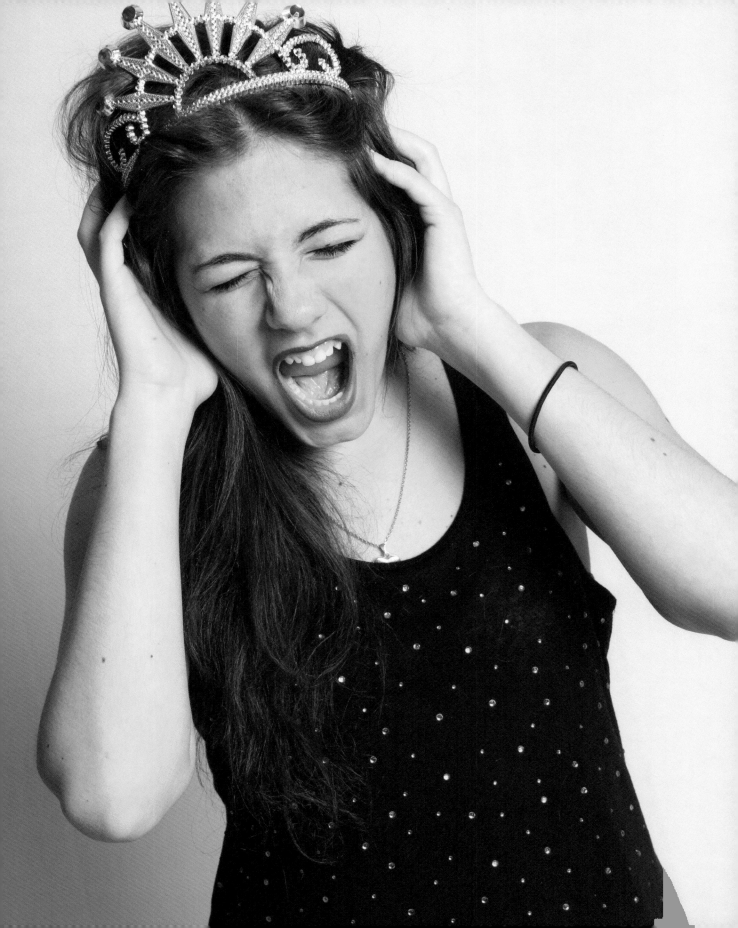

Dear Gaga,

There are times in our life, where there seem to be obstacles presented to us that we can't bare to deal with. Our dreams have been torn from us. They can come so suddenly, that you may feel yourself slipping in the process, clinging to your last hopes but you cannot let them drag you down. Many of these bumps in the road are inevitable. This injury, contrary to what many in the media would hope to see is NOT, nor could ever be the thing to dim your shine. Rather, you will rise from the flames like the Phoenix you are. You are the flame that illuminates us all. Seeing your letter to us the other day on Little Monsters, moved me to tears, because I thought of all the events that tied our community together, but I also thought of all the horrible events that happened to me personally. Deaths, my grandmother's hip surgery (if she could do it, you can too!), and most difficult, my parents losing their jobs. The sadness and the daily struggle in my household is painful to bare, and there are days where mentally I feel destroyed seeing my family suffer and the thought I could be homeless. However, MONSTERS, this wonderful community sparked by you, and your MUSIC, tell me that this isn't the end. I have my own dreams, something to live for, and as long as I still have a roof over my head, I will keep fighting.

Thank you for bringing us together, and for all the fans I talk to across the world. Stay strong honey, hold your head up girl, we're in this together.

Forever.

Love Always, Your Little Monster
Yonkers, NY

Where do I even begin to write the most influential and inspiring person in my life. Let's just say, you had me at "Just Dance"! I remember hearing that song and of course I was moving my ass to the great beat, but the words were so relatable. I was frequently overindulging in drinking which always led me to loosing my shit, and quite frankly all I wanted to do was loose myself on the dance floor. Since then, I have thoroughly enjoyed the journey with you. Many people ask "Why do you love Gaga so much?". Well: Besides the fact that you are the sexiest woman alive - no really you are absolutely gorgeous ... your eyes, those lips, boobs, that BAM!

And besides the fact that your musical talent is just jaw dropping. Your voice sends chills down my spine and there's nothing I love more than the rawness of just your voice and those delicate fingers stroking the piano keys.

All that aside, I am most drawn to your spirit. The message of your soul has captivated my heart. You're brutally honest in the words that pour out of you and that, despite what any criticizers say, is all we as humans yearn for - the truth. The truth sets us free and allows us to heal. You have helped me in telling my truth. Just before turning 30, about 2½ years ago, I was not in a good place. I was terrified of coming out as a lesbian to my family, I was on the verge of suicide, and felt completely lost. It was your words, you bravery, your life story really that picked me up from off the floor. I would play your music over and over again, until I was able to "Marry the Night" and believe once and for all I was "Born This Way". I will be grateful for you the rest of my life. Every time I hit my shit, because we all do, I play your music and know I'll get through it. Thank you for being you

Little Monster
Utica, NY

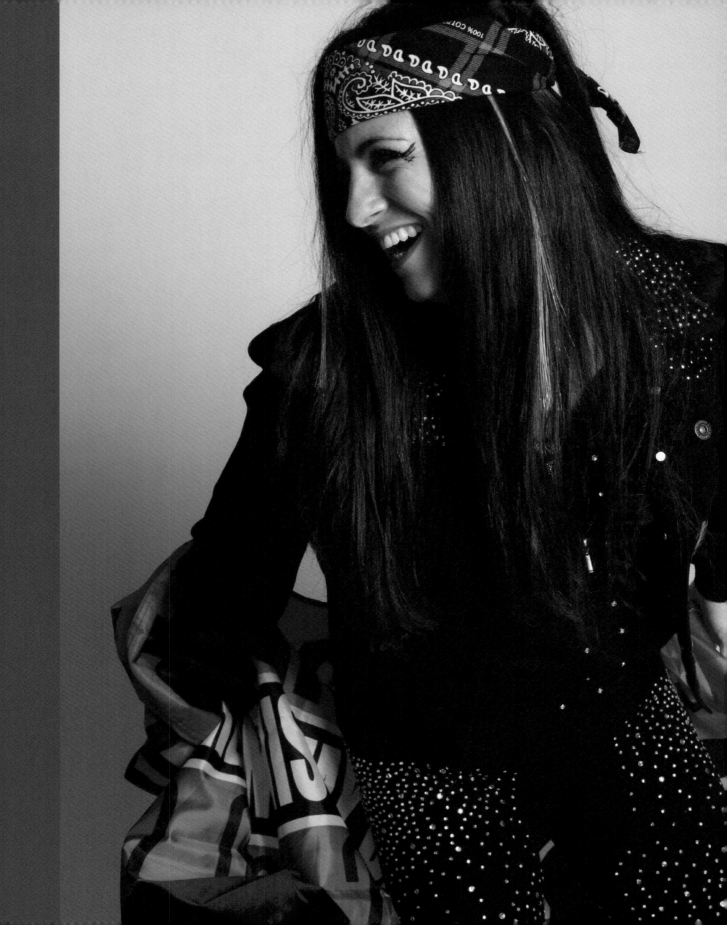

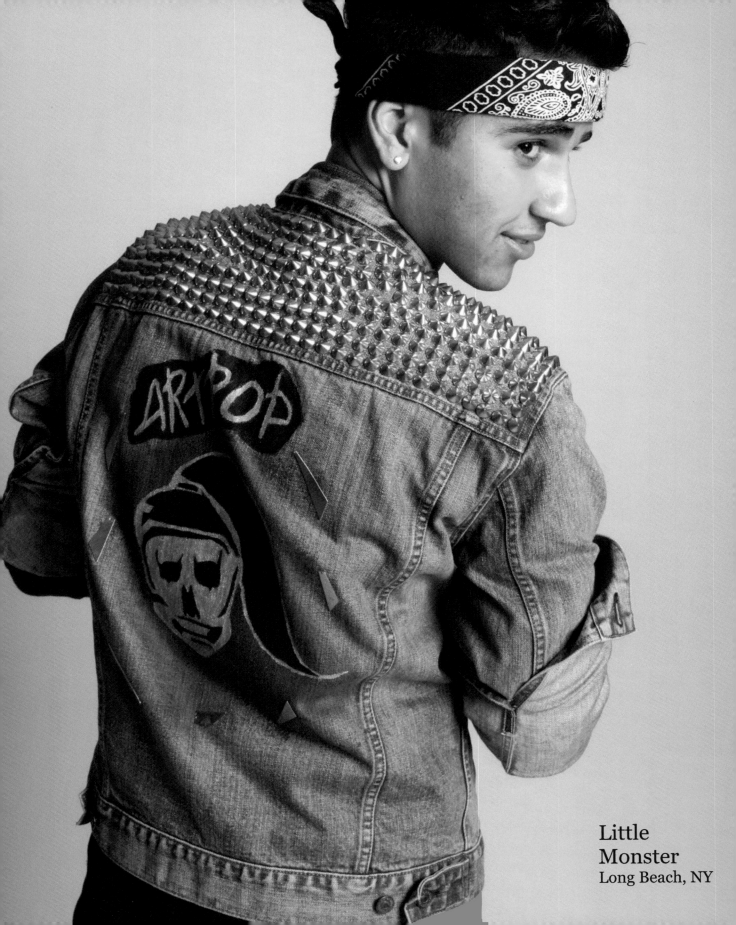

Little
Monster
Long Beach, NY

Dear Gaga,

I want to start off by saying you are one of the best things that has happened to me, Although you probably hear this a lot. you have made me strong, comfortable, and so open minded. I grew up in a very strict religion where homosexuality was frowned upon but coming upon discovering you I was able to see that everyone is equal and that everyone was "Born This Way". Along with the fact that u opened my eyes you helped me cope with more personal issues. I have always resented myself and hated my looks (my big Italian nose. and the the fact that I was fat, gurl you can't even imagine), you helped accept the way I look and now I think I'm pretty damn sexy. You inspired me to lose weight and so far lost 100 pounds. you have made me strong and unbreakable, you are my queen in every way possible and define the word in my life. l also wanted to thank for my phone call on 4/29/11 outside of the Oprah show for my birthday it made my life <3. I knew since the time I saw your work it was the just dance video when it first came out, in the back of an American Eagle store I said **"Wow this bitch is crazy humping an inflatable whale..... I like her, she's going to go far in this business"** and shortly u became the queen of pop. I was so upset when I hear you were in pain while touring, knowing that you must have been hurting so much while you busted your butt to perform for us made me sad. When l heard you had a lateral tear in your hip that made me even more concerned for your health and future. You canceling the born this way ball was the smartest decision, and I want you to know **NONE OF US MONSTERS ARE MAD AT YOU,** and if someone is, then they aren't a true fan. Your tickets were the only thing I saved from my house when it got flooded with 5 feet of water during hurricane sandy, I had 3 shows to go to, one at one at Barclays. and me and my mother were going to fly to Miami to see you as well. but I don't care that my shows were canceled because l know they are for a good reason so the queen can become healthy. I pray for your health and safety you gorgeous angel. I will FOREVER love you and thank you for all you have done for me and all you have done for millions of others; you have made me a better person. Get well soon gaga <3

- Monster Love

Little Monster
New York, NY

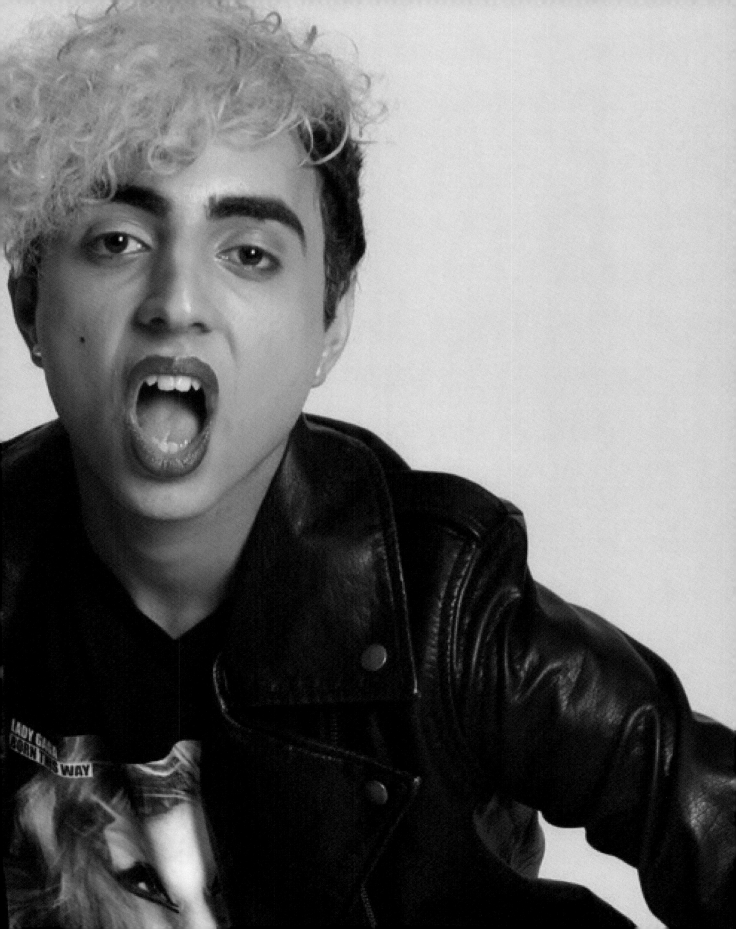

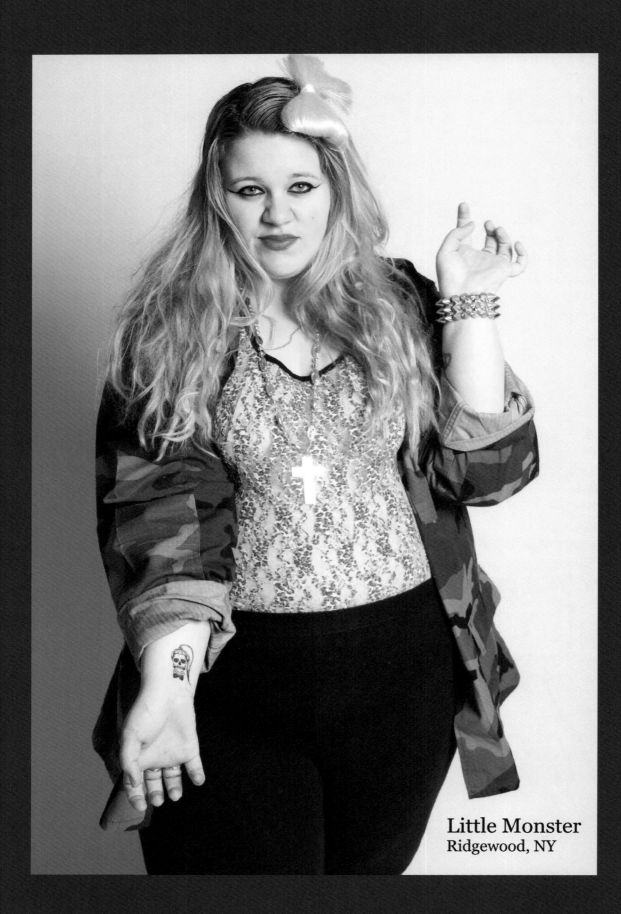

Little Monster
Ridgewood, NY

To My Queen Lady Gaga!
I can't begin to describe how I
feel about you. You inspire me everyday
to be brave. Since Born this Way
album came out I've been through
alot of difficult times in my life.
You remind me to stay strong,
brave and beautiful every single
day. You tought me to be confident
no matter how I look. The lyrics
to Bad Kids "don't be insecure if
your heart is pure"(which I have
tattooed) touched me. When your
heart is pure nothing else
should Matter. I want to
personally tell you thank you. You
helped me become who I am
today. Strong, independent,
beautiful, pure, free as my
hair! I love you

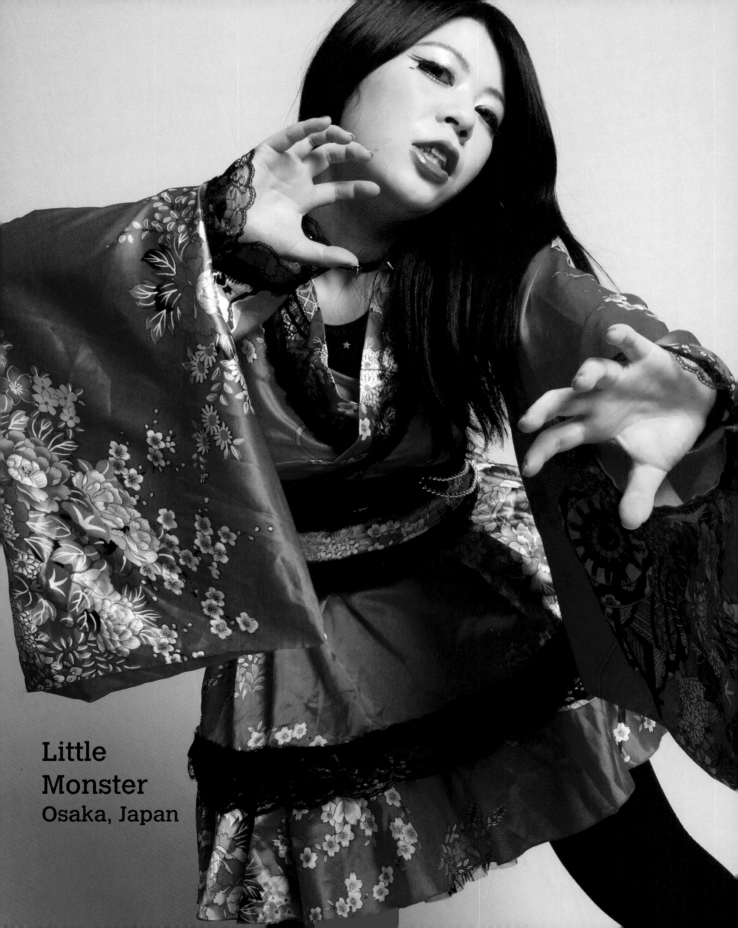

Little
Monster
Osaka, Japan

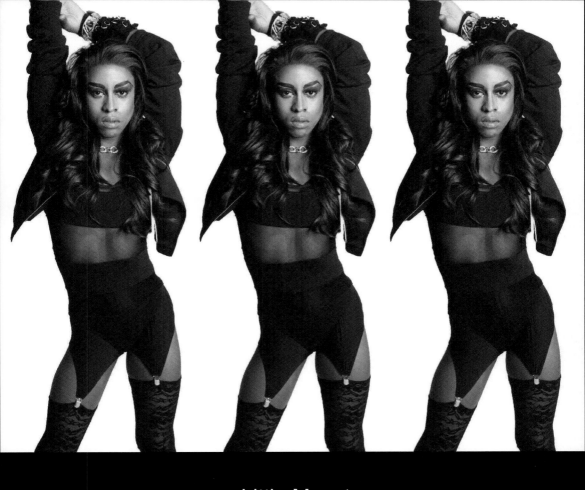

Little Monster
Fairlawn, NJ

GAGA ★ "Oh My GaGa!" "I AM A BAD KID!"

Mother Monster!!! xoxo ♡ xoxo

I don't know what I would say or do If I Ever meet you.... I've been a fan Since the burlesque days with *.Lady Starlight.*♥ Almost 8 years! You have been an inspiration to me.... Every Tear, Every Laugh, Every Smile, Every song. Your words of wisdom have brought light Into my darkest times. Your acts of courage, Kindness, and Bravery have made me feel less afraid of myself and the world... Finding More Good out of the Evil in Everything. I'm actually at a loss of words and cannot describe all that you have done for me =:) And how ~~greatful~~ Greatful I am for the birth of Mother monster and all of us little monsters!! "Paws up!"

In a Nutshell!!!. I'm So happy I could die* X :) ★★

Just Remember we are your Family also. So through all of your ups and downs we will be there for you, No matter what!! we were Born Brave!
I hope we can meet one day!
-Kiss, Kiss, your little monster.

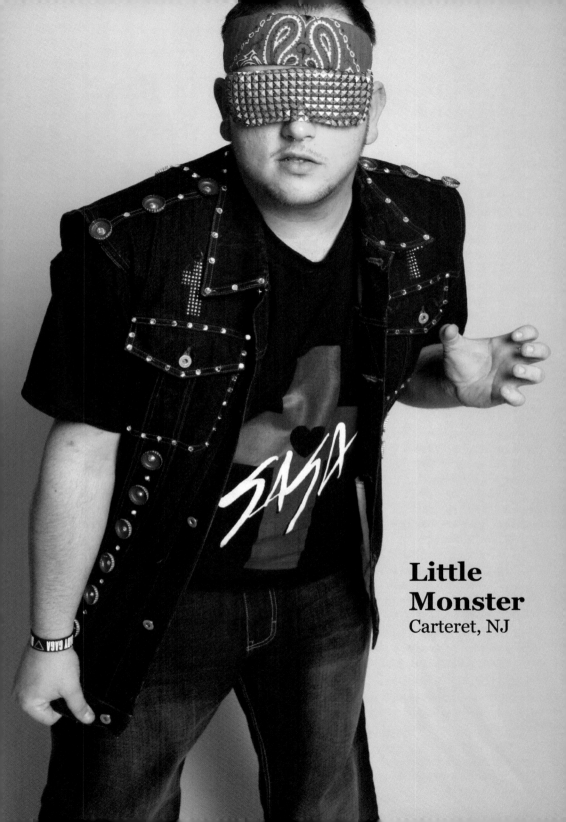

Little Monster
Carteret, NJ

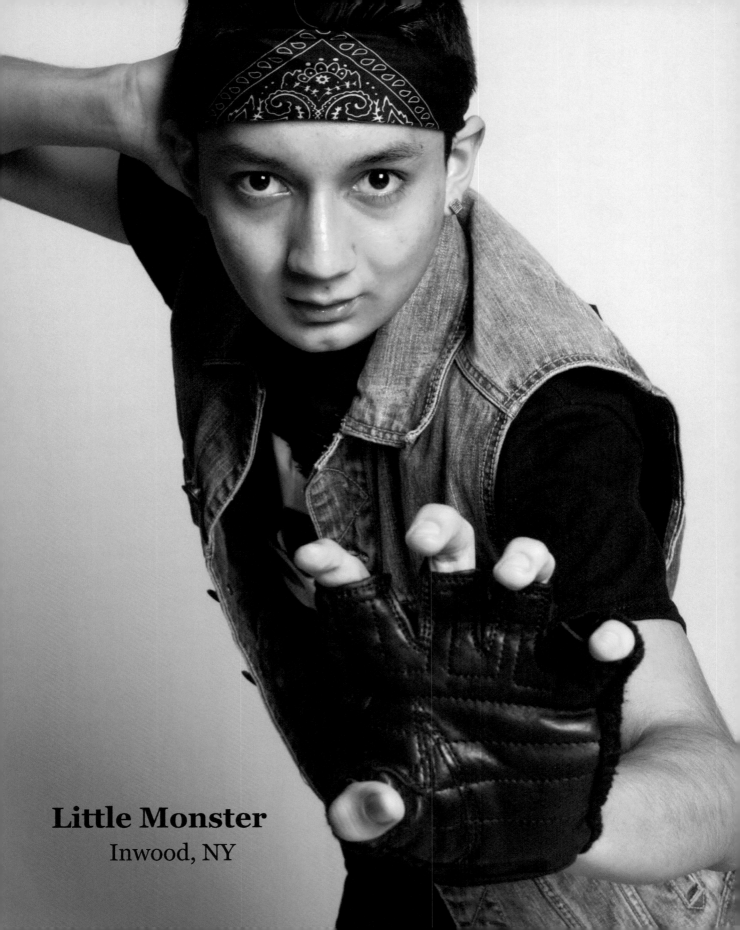

Little Monster
Inwood, NY

Nothing will ever bring you down, not even this small bump. You've taught me to say, **"Fuck the world! You don't like who I am? Go home!"** You taught me that, and for that, I thank you.

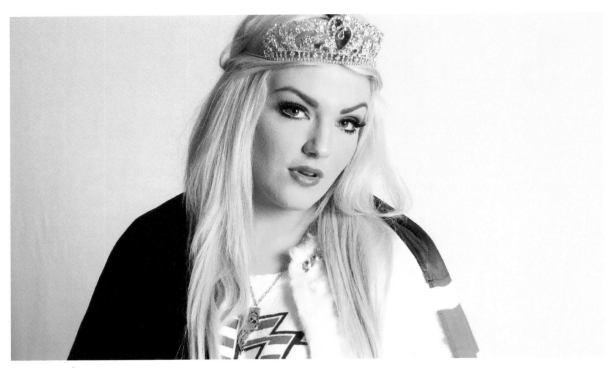

Australia

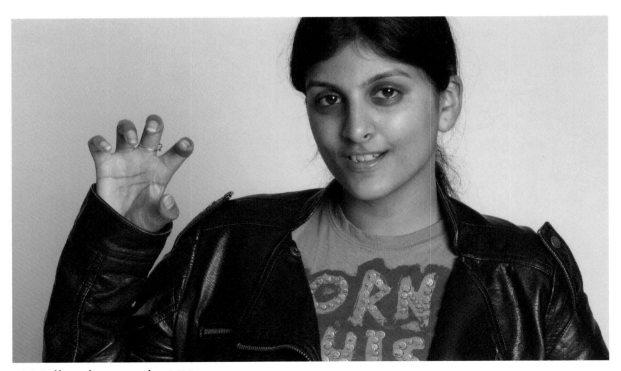

Wellingborough, UK

Saint-Pierre

New York City

Dear Gaga,

I love you SOOOOOOO much. I hope you are doing well and hope you recover soon so you can slay bitches again. Although I'll never get to see the Born This Way Ball in person like I hoped I would, I'll eventually get over it when the ARTPOP Ball is upon us. Don't you dare for a second feel sorry about canceling. You deserve it. You've been touring your ass off since 2009 and your body needs to rest. ARTPOP can't be lackluster so you need as much rest as you can get. Anyway let me get to the gist of this letter. I just want you to know that you mean everything to me and you won't ever truly realize how much because it's more than just putting them into words. You give of yourself for us (monsters) so much and I can't express how much it means to me. You seem to be one of the few that care about your fans and for that, I'm grateful. You have no idea how many people have wanted me to stop listening to your music and don't understand why I love you so much. I've been made fun of countless times because of my love for you. I guess not even little old me has any fucks to give. **cues Bad Kids and starts doing choreography** I wish to meet you someday so that I can touch you (not in a perverted way haha) and know that you really exist and aren't just some perfect hologram that was created by mad scientists (Haus of Gaga) years ago. I wish nothing but love and happiness for you during your break. Make sure you don't forget about us and most importantly don't forget about me. I love you and when you get lonely, I get lonely too. When you are scared, I'm scared too. But we are brave and that is the fame. I know that wasn't the exact phrasing of that piece but I made it up in my own way and chose to remember it this way because of how I artistically we can change things of the past (aka my attempt at bringing my own Marry the Night into this letter). I'll see you around NYC sometime since I live here for school. Remember that if the world stops believing in you, you can always count on me sticking by your side. I love you.

Love, a little monster heart

New York, NY

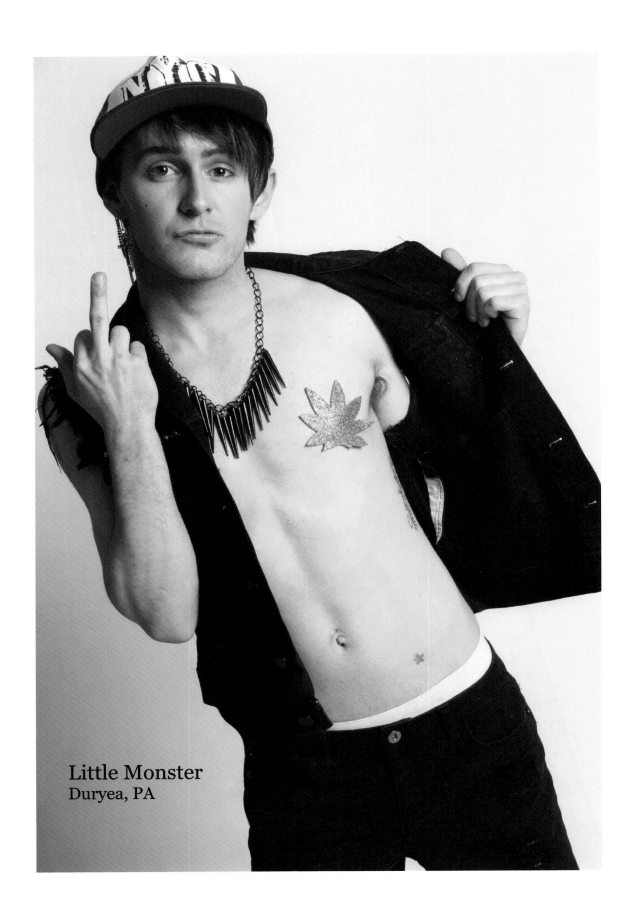

Little Monster
Duryea, PA

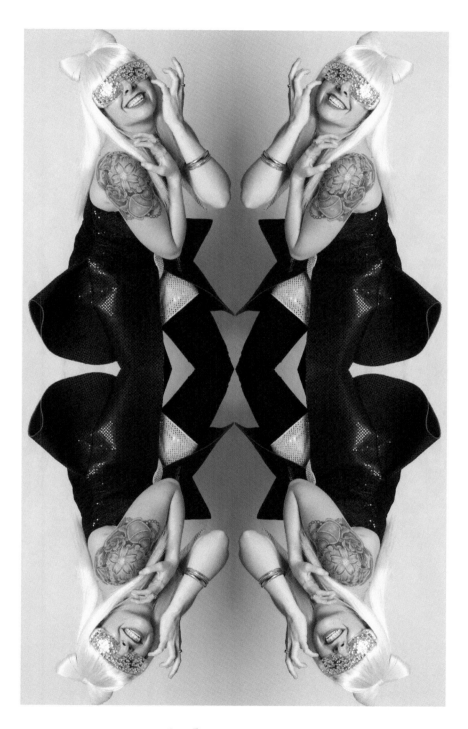

Little Monster
Washington, DC

I went to an all girls catholic high school, just like you. As you know, girls can be cruel. Luckily, I live in the greatest and most accepting city in America. New York City! Whenever I am low, or need some encouragement, I turn to your music. I listen to Hair over and over again. In all honestly, you make me feel so accepted, and so loved. Your strength gives me strength. I am a person who preaches equality and acceptance. I have given many speeches in front of classes about bullying and such... somehow I always incorporate your name. I am better because of you.

I am proud to be a little monster!
I love you!

Little Monster
NY, NY

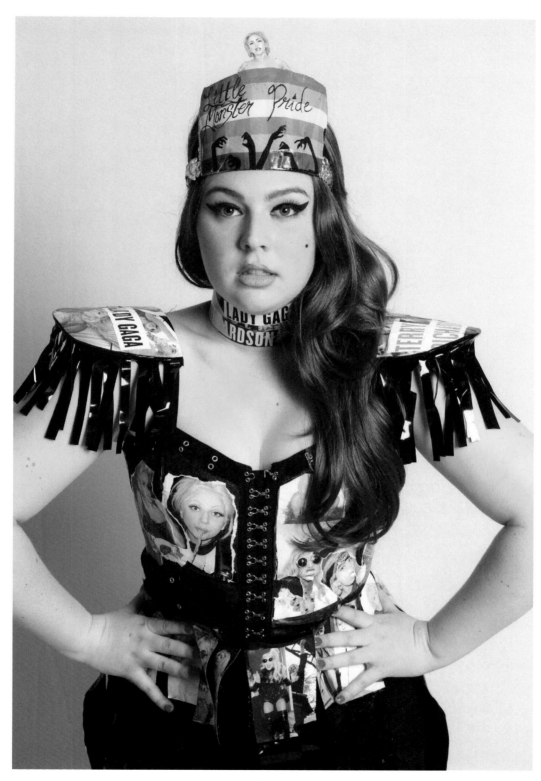

Little Monster
Hamilton, ON, Canada

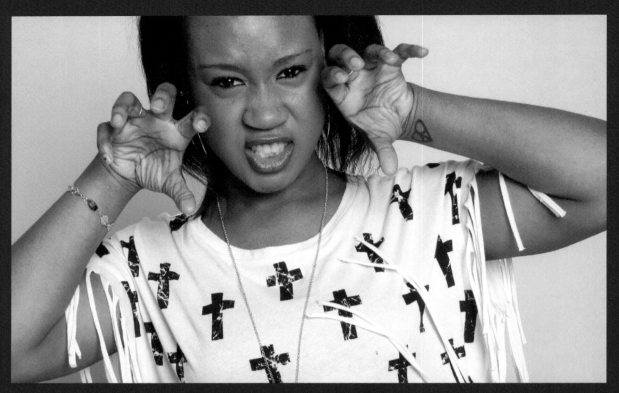

Dear Gaga,

I would just like to thank you for all that you've done for me.
Before your music, I was very reserved and unwilling to express who
I was on the inside; a crazy, fun loving person. I was too afraid of
people looking at me and judging me. But when I started listening
to your music and understanding the purpose you were trying to
fulfill, I became the brave monster that I am today. I don't give a
damn who looks at me or talks about me.

I'm being myself and it's so much fun.

Little Monster
Amityville, NY

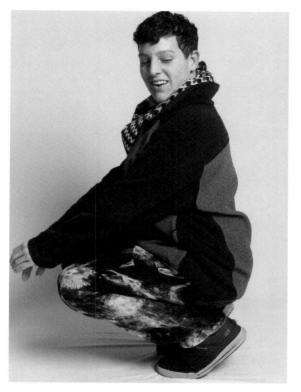

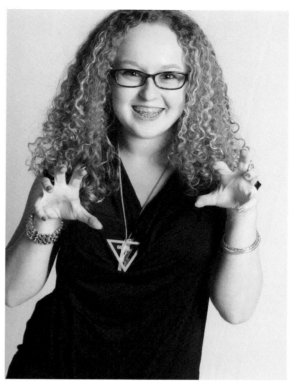

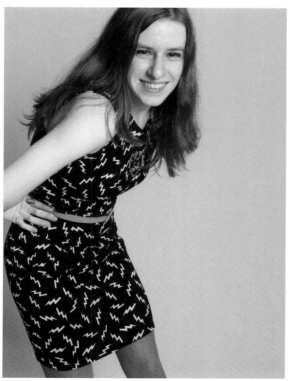

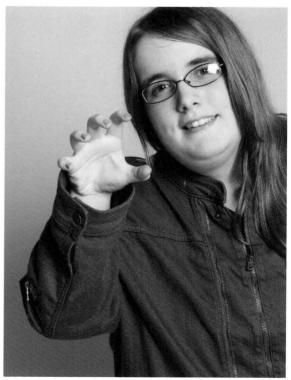

Waterford, CT
Stratford, CT

Wantagh, NY
Shelton, CT

there have been many times where I felt like I wasn't going to make it, but watching your interviews and listening to your words always uplifts me. You rise above all the sh*t talkers and keep a positive and loving attitude no matter what and that is inspiring. You have a beautiful soul and help us all to be stronger and more compassionate people. Your monsters love you very much and we'll keep praying for your full recovery. Get Well GAGA ♡

Little Monster
 Queens Village, NY

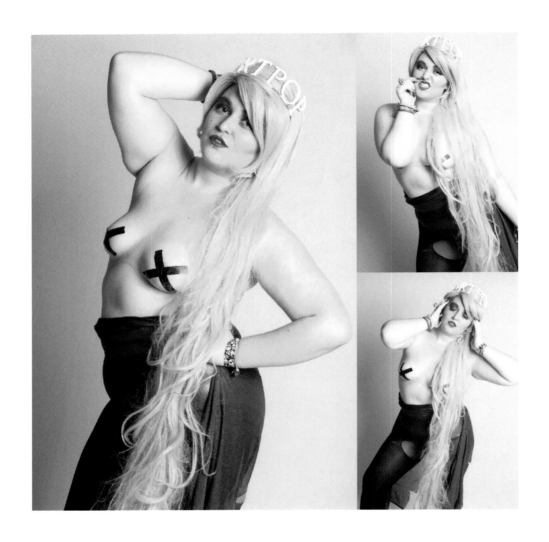

Little Monster
Victoria, Australia

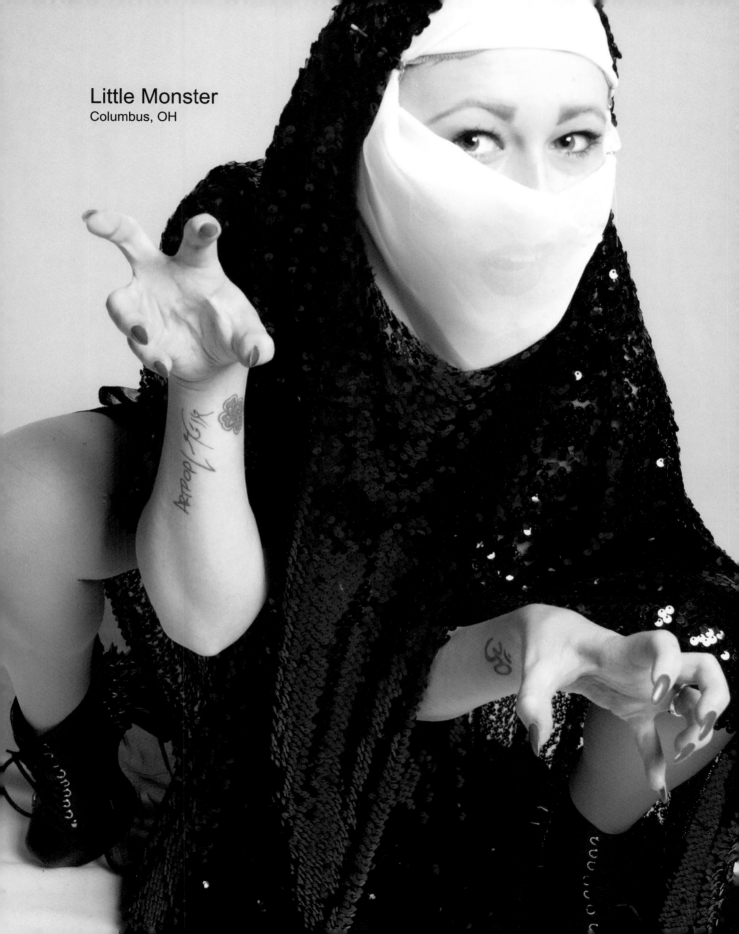

Little Monster
Columbus, OH

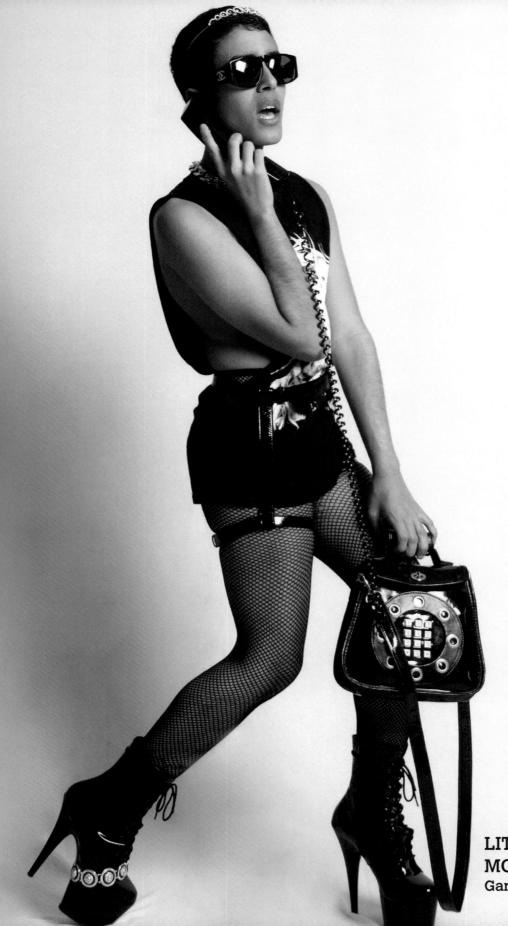

**LITTLE
MONSTER**
Garfield, NJ

...it's hard to express your true self when you have been bottling it up inside for years; afraid of what others may think of you. I basically lived in a lie my whole life and I was not sure how to break away from it. And to be honest, I was afraid, not knowing what would come out of this 'change.' I was expected to be a certain person; not having any flaws, amongst other things. It was just really hard pretending to be someone who I was not and pay no mind to my 'true persona.'

You taught me how to be brave and that I should not really give a shit to what others think. I have you to thank for that because if it were not for you, I do not know what would have happened to me.

A Thankful Little Monster

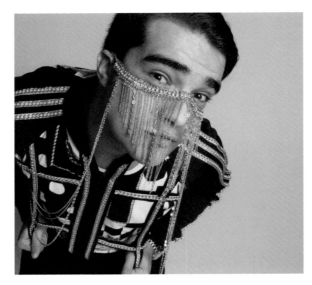

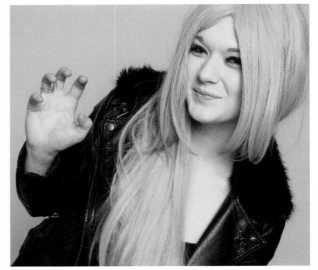

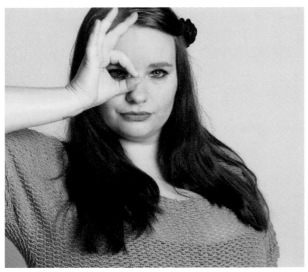

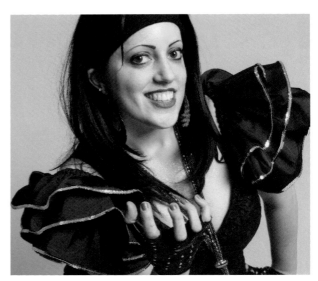

New York, NY
New York, NY

Mansfield, England
Alexandria, VA

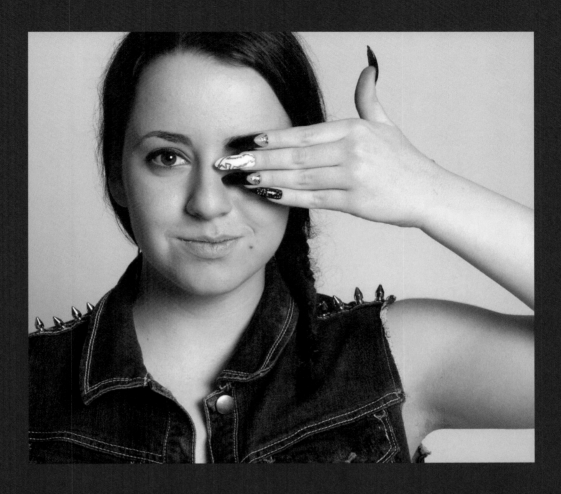

You've created this amazing family that I am so proud
and grateful to say I am apart of. And I literally owe you
everything for bringing us together. You've given me
some of the greatest friends I have, music that makes
me brave, and an amazing idol to look up to.

Little Monster
West Harrison, NY

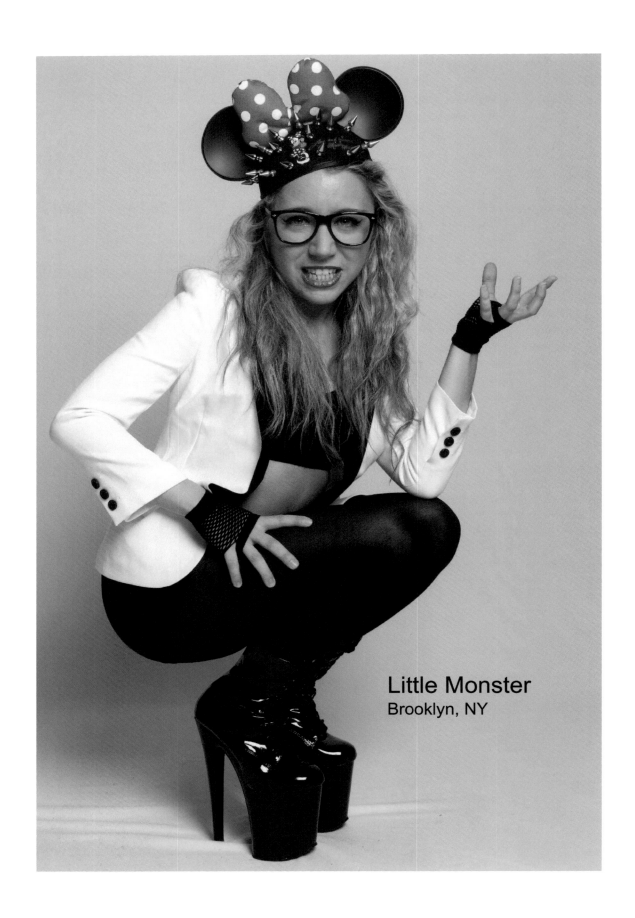

Little Monster
Brooklyn, NY

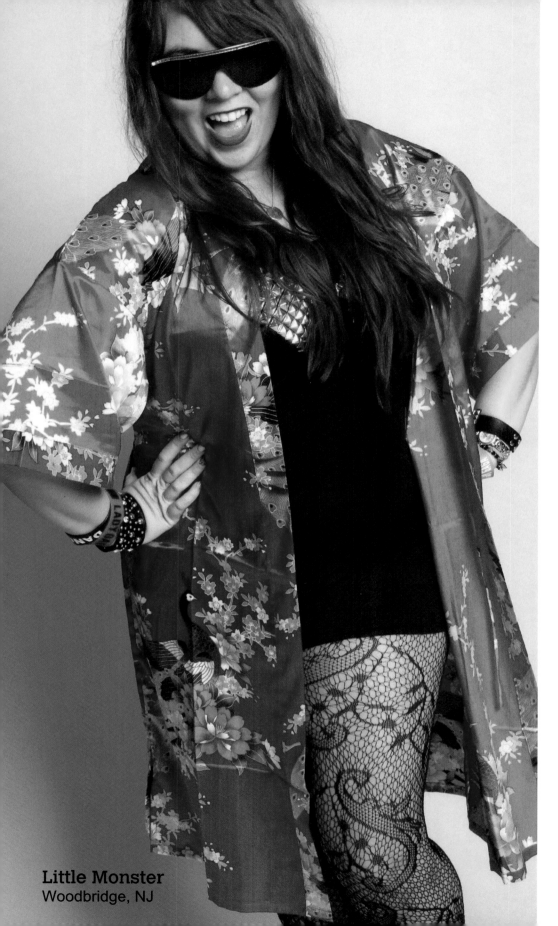

Please take this time to heal and don't push anything.

I'm suggesting for ARTPOP Ball, that you be kind to your hip and your health.

Maybe have some stunts in a harness to keep off your leg.

Or what about a magic carpet ride!?!

Little Monster
Woodbridge, NJ

hey sis,

gurl, hearing about the tour cancellation was like the worst case of blue balls EVERRRR. even though we had 5 more shows worth of damage left to do, your physical and mental health is so much more important to me. i must say, i was about to turn it the fuck out for you in new york, but those outfits will just have to incubate until the ARTPOPERA ;) luckily i was able to see the show 5 times between puerto rico & california (my bank account is sending me death threats now but whatevs) i know there's millions of fans who didn't even get to see it once, so i'm extremely grateful. to be honest, the most disappointing part of the news was that i never got to see you flip that flawless new green side part :(((no fairrr! so the moral of the story is: LISTEN TO YOUR BODY. stop fucking around and please take care of yourself, you have years of weave snatching left to do so you can't start falling apart on me now! thank you for showing me the time of my life at the born this way ball, i love you.

xoxo
little monster
nyc

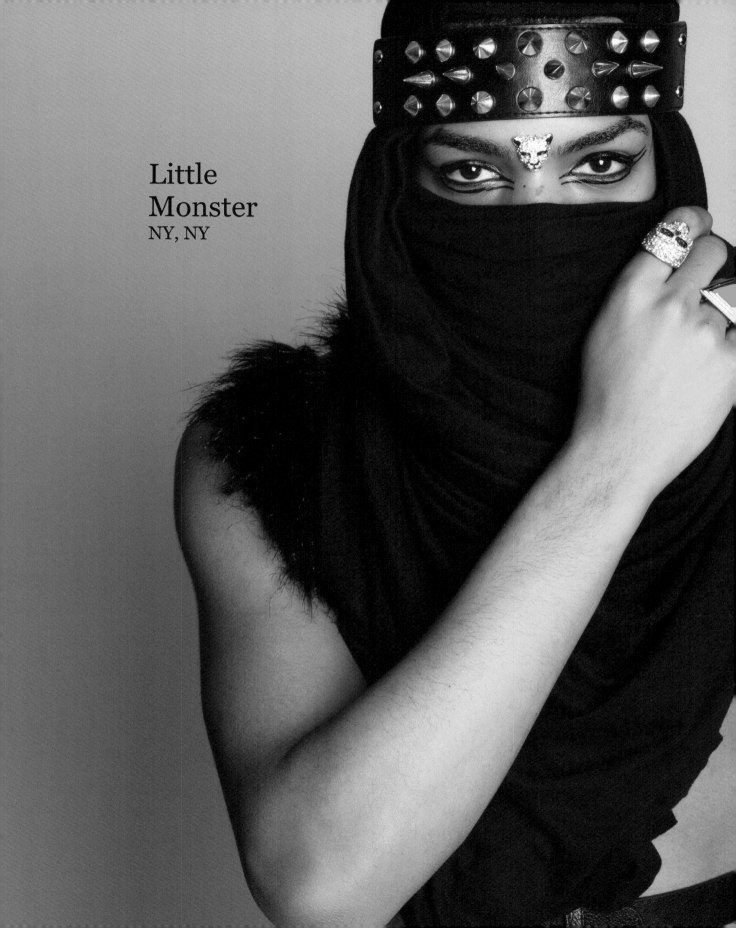

Little
Monster
NY, NY

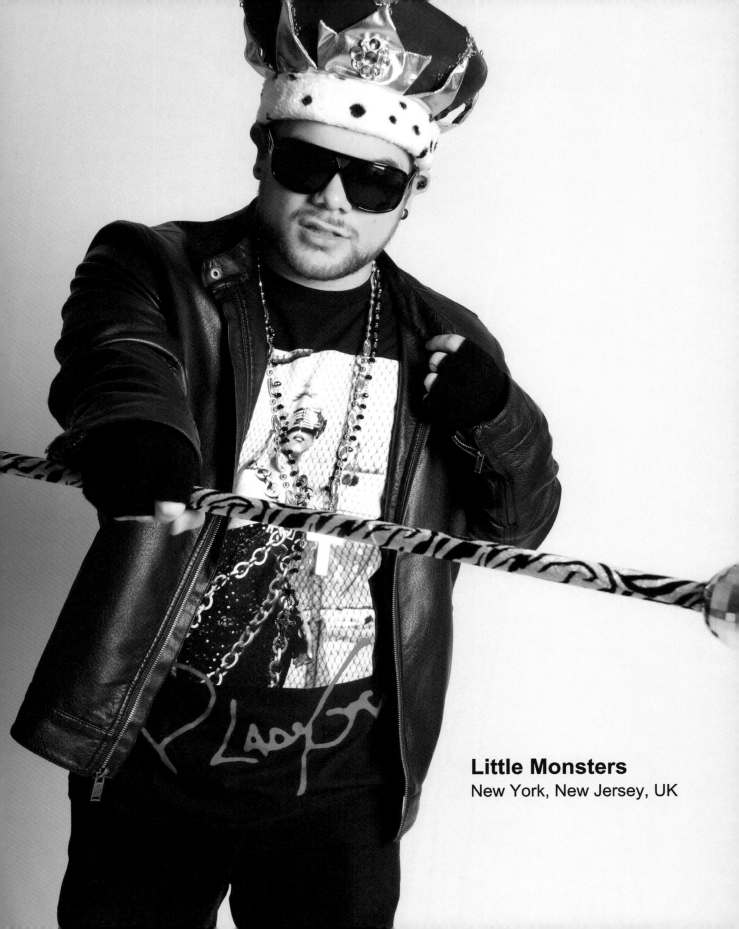

Little Monsters
New York, New Jersey, UK

 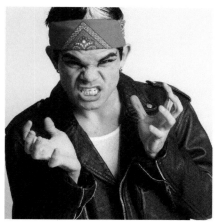

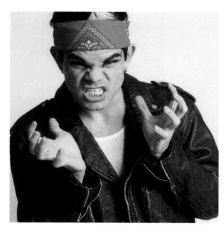 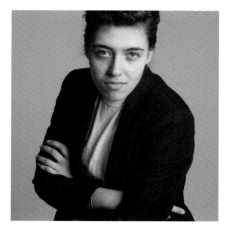 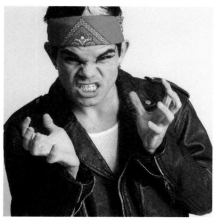

Dear Gaga,

I just wanted to say thank you. Thank you for always being so generous and giving towards me, and thank you for helping me love myself. I honestly do not know what my life would be like without you and I'm so lucky to have you in my life.

We wanted to celebrate all that you have accomplished with the BALL and get together with monsters who weren't able to experience it, and create something new: for YOU.

I love you more than my own self, and that is only because without you, I wouldn't be who I am today. (Don't worry, I love me a lot too ;)) Anyway, I'm sending hugs and kisses and a few gently rolled blunts your way! Take some time for yourself; we will be here when you're ready. I love you so much Gagaloo.

Yours forever,

Little Monster
NY, NY

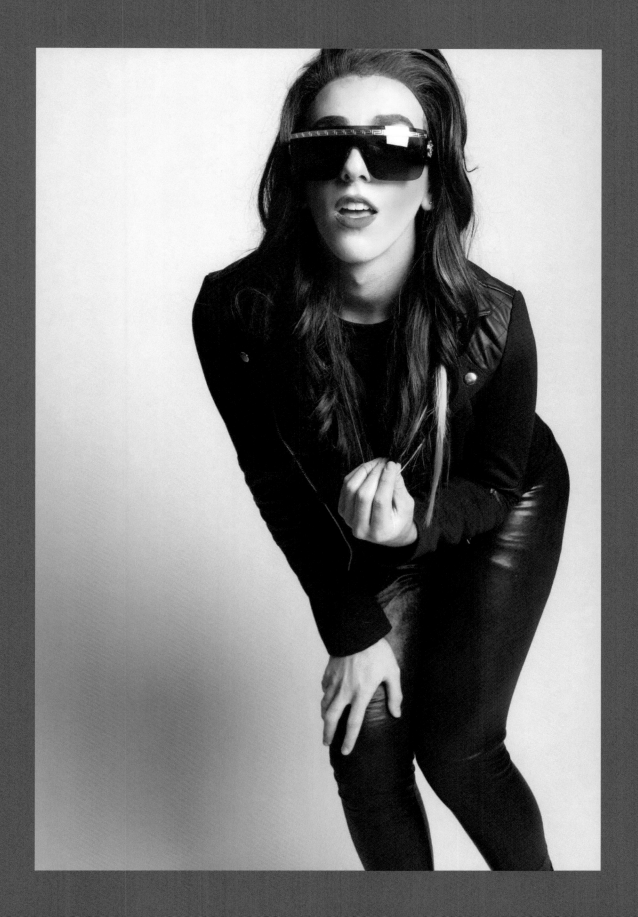

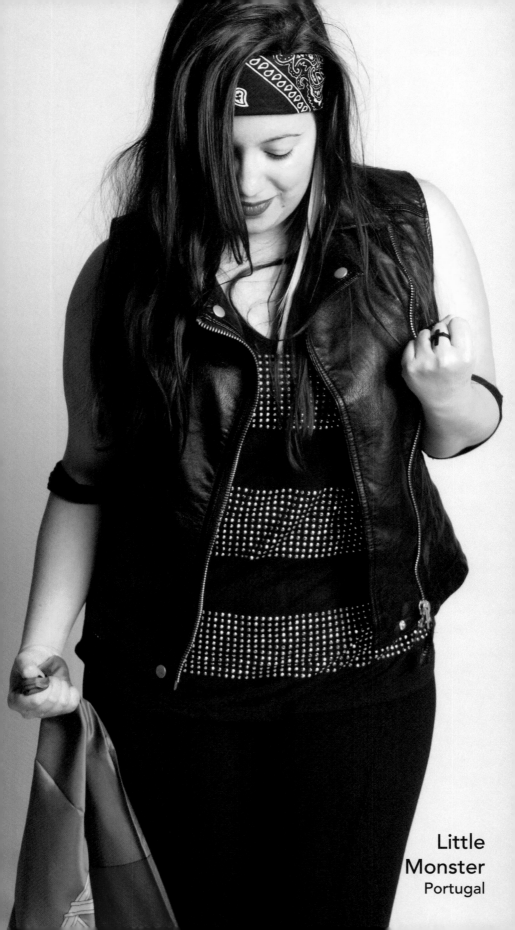

Little
Monster
Portugal

Scotland Monster

Scotland Monster

The BTWB will always live on,
because of the lessons we were taught during it.
To breed love and compassion,
to stand up for yourself,
and to not let anybody take away your identity.
The BTWB lives on inside us all!!!

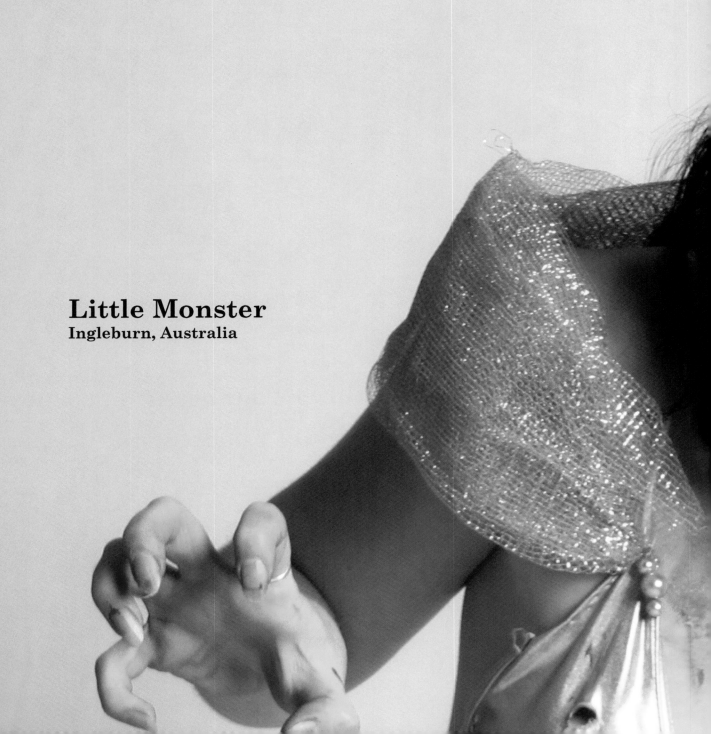

Little Monster
Ingleburn, Australia

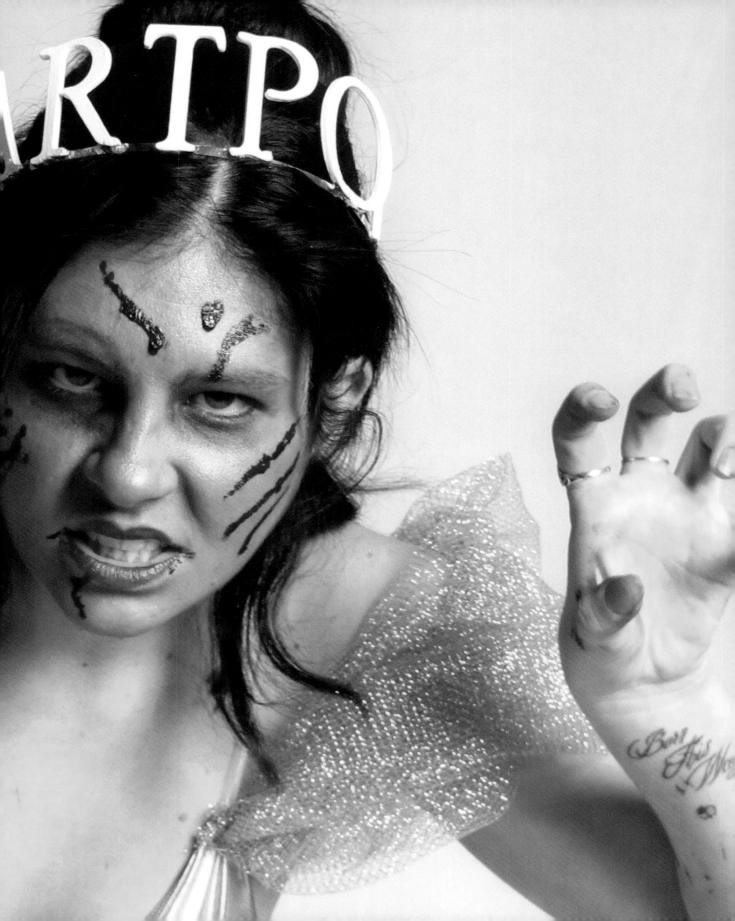

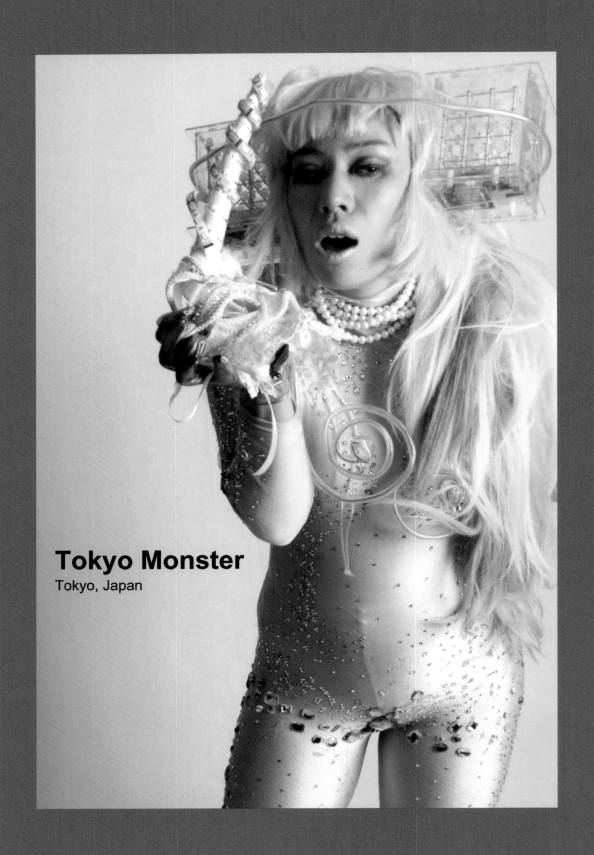

Tokyo Monster
Tokyo, Japan

Gaga-

　　Your amazing performances, outrageous outfits and flawless voice are what make you a pop-star. But what sets you apart from all the rest is your tremendous **HEART.** You are always giving 100% of yourself -- In your music, in your relationship with your fans, and onstage. Now is the time for you to sit back and receive the love and healing thoughts that we are all sending your way. Our fanbase is a family, and this is what families do in times of adversity. They stick together and their relationship grows that much stronger.

　　My kids and I had tix to 3 NY shows. I was taking them in that Monster Pit and we were going to dance, dance, dance and celebrate the ball with you. But, all of that can wait. We are now only concerned with your health and well-being. I know that each day that you feel this love from your fans, family and friends will make you stronger. For now, we will dance in my living room and in my car and in any store that happens to be playing your music. I love you, believe in you and am *SO PROUD* of you and everything you stand for. **Always.**

Monster Family
Howard Beach, NY

I hope you remember that you made a promise to us to Marry the Night, and as long as you breathe to never give up fighting for all the things we believe in together, a promise you made with us before we even knew it.

I hope the message you take from all the words in this book was one that reassures you that we believe in you, and we believe in each other, and when you're not there to pick us up, your voice is with us, and we can share amongst each other all the strength and bravery we dreamed up together.

We are never alone as long as there are Little Monsters. And although most of us may never meet you, you better believe we will love you in every way forever. We are all fucking Superstars, isn't that what you said? So never fucking forget that, and neither will we. Keep fighting, we are waiting for you to come back better than ever. That isn't pressure, that is fate. And a little sip of Truth Tea, darling.

Infinitely Yours,

A Grateful Little Monster
Fort Mitchell, KY

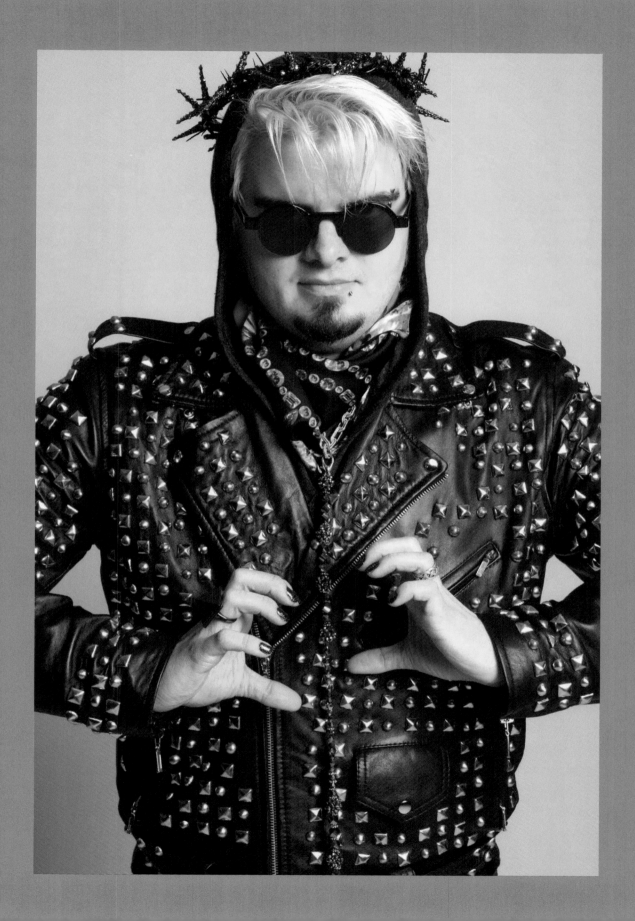

Not
The End

Epilogue

After our Born This Way Ball was cut short, something happened that none of us who had tickets for the cancelled MSG shows had really planned. We got together anyway and made it a really special day, filled with all the things we had hoped for - a celebration of an era that helped redefine our vision of pop music, helped redefine fashion, but most of all, helped us redefine ourselves.

With the gracious Little Monster photographer, Tracey Wilson, we made a get well gift for Gaga that weekend - a book filled with the promise that the Born This Way Ball would never be just a concert, but that it would be a way of life we will forever embrace in our hearts.

The Born This Way Ball was 99 shows of spikes, hair, and leather, but ultimately it was just the beginning of a celebration of self love that we will never let end.

Thank you, Gaga.
We love you.

And because of you,
we love ourselves.

XOXO
The Little Monsters

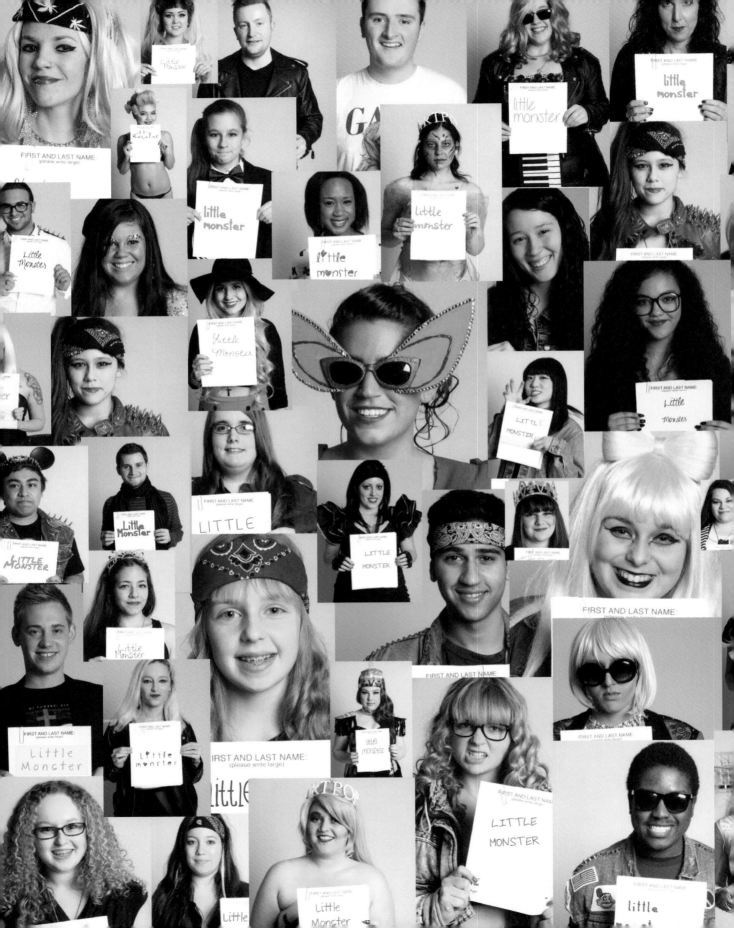

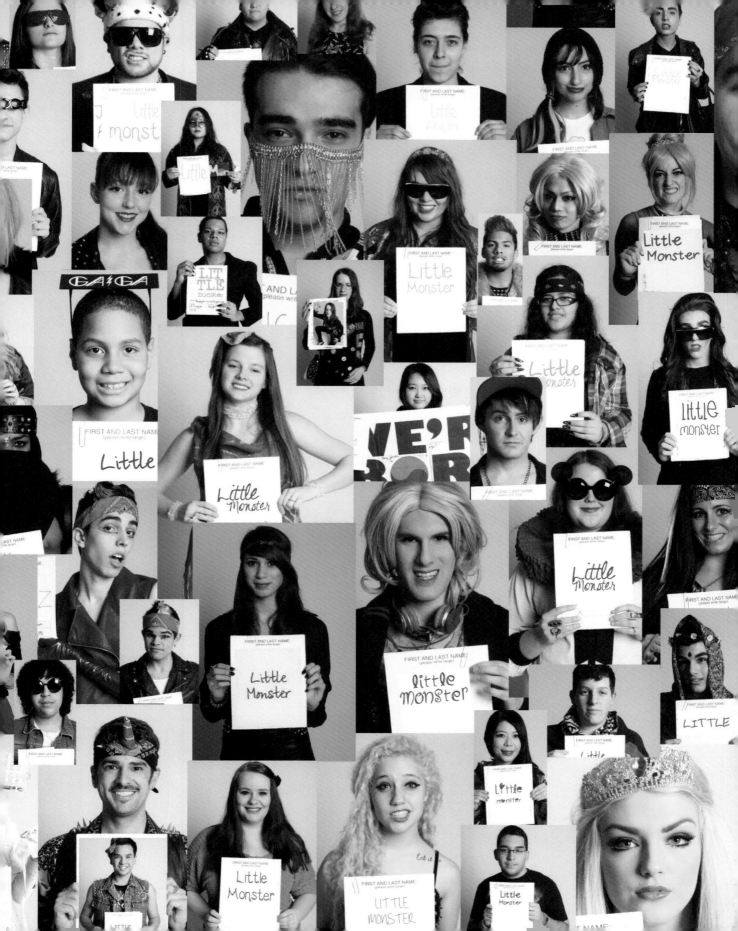

Bulk orders available for charity events,
and for groups using HEAL THIS WAY as a teaching tool.

Contact:
HOT GLUE PRESS, LLC
2268 31st Street, #5500
Astoria, NY 11105
212-419-2306

info@hotgluepress.com

If you are interested in scheduling
an appearance, photoshoot, or special event
with author/photographer Tracey B. Wilson, please contact:
events@hotgluepress.com / 212-419-2306

ORDER MORE COPIES!
www.healthisway.com

Share your thoughts with us!
www.facebook.com/healthisway
twitter @littlemnstrpix @healthisway

A portion of each book is being donated to charities promoting acceptance
and social equality.

Published By
HOT GLUE PRESS, LLC